Learning First in Black and White

Learning First in Black and White

A Comprehensive Course in Art Composition for Instructors and Students

By Diane Solvang-Angell

Learning First in Black and White:
A Comprehensive Course in Art Composition for Instructors and Students
The first in a two book series on *The Design Code* ® Process

Cune Press, Seattle

© 2012, 2021 Diane Solvang-Angell
All rights reserved
A product of AngellWørks

ISBN 978-1-951082-08-6 Paperback $20.00
Second Edition. Revised and updated.

"CIP information from the Library of Congress is available on request from www.cunepress.com"

Learning First in Black and White includes bibliographic references and an index.
Unless noted, all artwork and photography are credited to the author.
The Design Code Process books are published with Fred Griffin's permission, based on
his idea-generating system. *The Design Code* ® is a registered trademark.

The Design Code ® Process, a two book series:
 —*Learning First in Black and White*
 —*Tossing Around Ideas (coming soon)*

Forthcoming, a new book by Diane Solvang-Angell:
 —*Creative Paths—How To Boost Imagination (a personal journey of visual discoveries through research, painting, sketchbooks, doodles, digital art, photo manipulation, and more)*

eBooks on iTunes/Apple Books by Diane Solvang-Angell:
 —*A Leap into eSpace, My Switch from Paint to Pixels*
 —*Run With It! Chasing Digital Doodles*
 —*Through the Lens and down the Rabbit Hole, a Graphic Picture Book for Visual Explorers*
 —*It Starts with the Eyes: Untold Stories Drawn on Glass*

Cune Press
www.cunepress.com
www.cunepress.info

ACKNOWLEDGEMENT

This book is dedicated to past staff and students of The Burnley School of Professional Art, and to all who find *The Design Code* an inspiring and useful tool. (For many years, Burnley was an independent art school, later purchased by the Art Institute of Seattle, and merged with its curriculum.) Many thanks to those who brought their expertise at different times to different parts of this project: Chris Angell, Yaravi Angell-Astete, Laura Arntzen, Kate Baetz, John and Kate Barber, Eric Chamberlain, Renee Corcoran, Scott C. Davis, Dennis Burns, Ron Carraher, Hunter Golay, Gina Hanzsek, Jill Hertzog, Iris Jaffee, John Kutz, Elaine Packard, Mary Pease, Bob Purser, Marjean Radford, Elaine Schmidt, and Teresa Shattuck; and to the Art Institute students who shared their thoughts. I would especially like to credit Fred Griffin's wife, Anita Griffin, and Annette Bauman and Marilyn Rygg-Nordell for their dedication to Griffin's *Design Code*. I would not have been able to do this project without their insights. And to those artists who wrote testimonials for this book: Jess Cauthorn, William Cumming, Rosalyn Carson, Doug Fast, Lisa (Hanson) Hixon, Ted Leonhardt, Gary Nelson, and David Rosenzweig.

Among those above who helped me at various times during the review process are: two computer network designers; two grade school teachers; a specialist in grade school art instruction; a specialist in home schooling; four professional art school instructors; four professional graphic designers with different training backgrounds; an art director at a computer game firm; two gallery artists; an author and college film professor; the program director for a community college graphic design department; the head of a college art department; a Chinese scholar with insights to the role that technique and myth play in that culture's art; a retired high school history teacher, college counselor and school administrator; an author-publisher; a retired scientist/watercolor artist; a retired alternative high school principal and math teacher; an art history instructor at an art school; a garden sculptor; a librarian in the Washington State Supreme Court offices and cookbook author; and a senior editor for the Washington State Supreme Court Reporter's Office. (In some cases a person represented had more than one expertise).

TABLE OF CONTENTS

PREFACE

This book is for two types of readers: those with an understanding of design—and those with no understanding of design. For those who understand design, this book is a tool to help oneself out of a rut—for those who are new to thinking about design, it is a primer in the basics of composition. For both readers, this is a book you can return to again and again for inspiration.

Learning First in Black and White introduces The Design Code process. *The Design Code* process is a remedy for an artist's equivalent of writer's block—when the well of ideas runs dry—because it's a system that helps generate fresh ideas rapidly.

In the same way that music theory has the capacity to describe every piece of music, whether or not the musicians performing that piece can read music, so can design principles be used to describe or analyze any piece of art.

The Design Code is to the visual arts what music theory is to music.

Traditionally, art is often treasured for its sometimes mystical expression. However, this book concerns itself with the logical side of art.

Northwest Artist and Educator, Fred Griffin—Originator of *The Design Code* ®

The Design Code is the brainchild of Northwest artist and educator Fred Griffin. It is an original system—defined and refined over many years. It looks at visual expression that we take for granted and breaks it down into a type of visual DNA. For many years, the system itself had no name, until one day he christened it *The Design Code*.

Developing this idea-generating system and inspiring others was Fred Griffin's life work—as an educator and artist. I saw *The Design Code* developed and refined first-hand, both as a student and later, as a professional colleague and practicing designer. Fred Griffin passed away in 2011. This book is a tribute to his efforts.

Many of us who were fortunate to have had Fred Griffin's direct instruction or to have taught with him have been deeply influenced by the experience. We credit his unique classification system as playing a large part in our winning awards in illustration, graphic design, film, and advertising. *The Design Code* process has helped in everything from challenging commercial assignments, to facing blank canvases, to starting new sketchbooks. At the end of this book, you'll find testimonials praising Griffin and his system.

AUTHOR'S PERSONAL NOTE

I first encountered Fred Griffin and his system as a student in art school, and I have used the system for years in the graphic design business, in teaching, in my sketchbook practice, and in my personal creative work as an artist.

I always thought Griffin embodied many characteristics one might associate with genius—intense focus, intelligent, reclusive—and a maestro's command of what to do with an empty page. When I first met him, his system was fairly well developed. He would demonstrate to his classes the basic elements of visual expression at their most reduced state and show how those basic elements were the essential building blocks for all composition. When assignments in his class were due, I often found myself either completely missing the point or exhibiting some hitherto unknown clarity, but not understanding *why*. Understanding that "why" has for years kept me fascinated with his system and given me a deep desire to share it.

At an earlier stage in the development of *The Design Code*, Griffin had pursued the idea of publishing. A large publisher had been interested, but in a peer review, it was suggested that the concepts represented a checklist rather than a system. After that, Griffin had more or less abandoned the idea of publishing—his true delight being teaching. (Those of us who regularly employ the system would have disagreed with that earlier "checklist" verdict—and since that time, he had the opportunity to thoroughly refine the system.)

After successfully using *The Design Code* for years in the design and illustration business, a small group of us revisited, with Griffin, the idea of publishing it. We wanted his system to enjoy a wider audience, and we began to work intensely with him to help ready the current version for publication—each of us contributing from our own respective professional backgrounds. Eventually, because we could not agree on the best approach or audience, Griffin granted us each permission to independently publish his system as we perceived it—based on our individual experiences and insights.

In the beginning, Griffin intended the system as a tool to teach design and illustration to art school students, but after earning an MAEd degree, I felt the information was needed at the K-12 level also, since design is actually a visual language—as foundational to the arts as grammar is to writing or numbers to math. My goal then became to create an easy-to-understand teaching manual about *The Design Code* process that could work on several levels. I think you will find this book satisfyingly sequential and comprehensive. You can view Griffin's personal art at: http://www.fredgriffinart.com.

4

THIS IS THE FIRST OF TWO BOOKS THAT EXPLAIN *THE DESIGN CODE* PROCESS. EACH BOOK IS COMPLETE IN ITSELF.

Book 1: ***Learning First in Black and White*** provides sound knowledge of design principles and includes a bonus section on idea generation. It also covers how to visually portray change. Each lesson is explained with geometric shapes, followed by illustrations of apples that portray the same concepts. Also included is a section that gives tips on how to dig deeper for better ideas.

Through many years of teaching design principles, Fred Griffin found that if students worked first in black and white, their grasp of basic design principles was much clearer than if they were dealing with the confusion of color. Color, a study unto itself, introduces an element of distraction—hence the title of the first book: ***Learning First in Black and White***. Each book stands alone and contains the entire code.

Book 2: With ***Tossing Around Ideas,*** examples from the first book are examined in greater depth, but now with an ocean theme. Information on color theory is included. The change to an ocean theme gives the reader an opportunity to develop a deeper understanding of the same concepts previously illustrated by the apple.

At the back of ***Tossing Around Ideas,*** there is a section of exercises to carefully walk you through *The Design Code* system, again. You will also see how the same principles apply to photography. When one learns *The Design Code* process, it becomes a dependable and systematic way to generate fresh ideas—so that when you approach a blank working-surface, your new habit will be to filter an idea through a variety of compositional suggestions.

Why Use the theme of an Apple and the Ocean, and Not Just Use Random Examples?

By narrowly restricting examples, the imagination is forced to focus—to be more elastic and inventive within those parameters. Thought muscles are stretched and critical problem-solving happens. And by employing two different subjects in variations on the same theme, there is an opportunity to compare ideas. This comparison yields deeper, more lasting insights.

(And—*The Design Code* was developed in Washington State—my home state, where the apple-growing industry dominates one side of the state, and the Pacific Ocean bounds the other.)

HOW *THE DESIGN CODE* WORKS: It has three parts. You will <u>select</u> from *Visual Elements*; <u>relate</u> with *Visual Relationships*; and <u>compose</u> with *Compositional Devices.*

Using the metaphor of a theatre tableau (a frozen scene), start with an empty stage (see below). You are the "director"—you are building a picture for your audience. ● Step One: SELECT a cast of actors and costumes from *The Design Code's* **Basic Visual Elements** section—**refer to chart on page 9**. Those "actors" will have names such as *line, plane, shape*, etc.—and their "costumes" will have names such as *color, texture, pattern, surface, etc.*) ● Step Two: RELATE (arrange) your chosen *visual elements* (actors) by using the **Basic Visual Relationships** section of the chart as your guide. You will play and experiment with their relationships in rehearsals. On the page-9 chart, *relationships* have names like *point-connect, edge-to-edge, overlap, pop out*, etc. ● Step Three: COMPOSE what the audience will see on stage at opening night curtain call. This overall "stage direction" will come from the **Compositional Devices** at the bottom of the chart. You will choose one *compositional device* only—there are eight altogether (let's say you tried all of them in rehearsals and settled on one). The title of your tableau (composition or picture) is up to you. I named my composition, below, "Playful Shapes."

The panels below, based on our theatre metaphor, show how *the three basic surface enrichments—color, pattern, texture* (in this case gray is subbing for color)—can bring interest to such basic choices as *line, plane, and shape. This is similar to how adjectives enrich nouns.*

Working-space = empty stage

[1] SELECT:

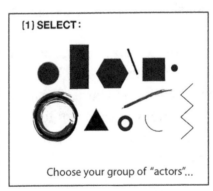

Choose your group of "actors"...

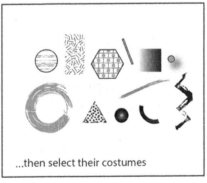

...then select their costumes

[2] RELATE:

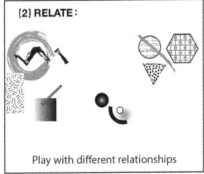

Play with different relationships

[3] COMPOSE:

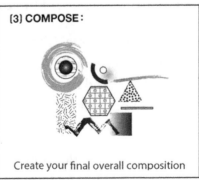

Create your final overall composition

*For the final panel, I chose the **Compositional Device** of **One Focal Point** (a free-floating unit [or cluster] that grabs attention).*

6

THIS IS THE DEFINITION OF DESIGN USED BY *THE DESIGN CODE*:

"Design is the <u>logical selection</u> and <u>arrangement</u>
of <u>visual elements</u> for <u>order and Interest</u>."

All lessons are based on the above definition. Design principles underlie all works of art—whether consciously used or not.

The decisions that go into artwork come from a spectrum of thought. On one end of that spectrum is orderly and planned thought—the type of thinking that might go into drawing a checkerboard—on the other end is expressive emotional feeling, such as a scribble might represent—where no planning whatsoever takes place.

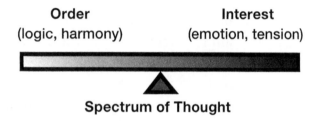

Order **Interest**
(logic, harmony) (emotion, tension)

Spectrum of Thought

A composition (work of art) might display a visual balance that is formal and *symmetrical*—picture two identical square tons of iron sitting on the ground side-by-side. Then visualize an *asymmetrical* balance—the volume of a ton of iron sitting beside the volume of a ton of feathers. The visual volumes (iron vs. feathers) would be unequal.

In your sketchbook, draw an orderly grid. Then add some lively scribbling to one box within the grid—even scribble over its edges. That small, spontaneous scribble immediately creates interest (draws attention) within the grid. You have placed a small amount of emotional intrigue in a rigid and orderly environment. On another page, do some wild scribbling. Now draw a box around it. You have just brought a small degree of order (control) to the scribble by corralling it. Both of these examples are a mixture of *order* and *interest*. The first example represents a balance of about 90 percent *order* (the grid) and 10 percent *interest* (the scribble). The second example represents a balance of about 90 percent *interest* (wild scribbling) with 10 percent *order* (the surrounding box). A *symmetrical* balance is thought of as a 50-50 balance—like the identical square tons of iron sitting side by side. Some people think of *symmetrical* as boring.

THINK OF *THE DESIGN CODE* PROCESS AS VISUAL LANGUAGE

 When you speak, you don't consciously choose the alphabet letters that will make up your words. Nevertheless, they make up your words.

And you probably don't pause to give consideration to the verbs and punctuation holding your nouns, adjectives, and other parts of the sentence together—you just speak naturally.

It's the same with *The Design Code* process. It's a visual language (aka: visual thinking) that can flow as effortlessly as conversation.

. . . CONTINUING WITH THE THOUGHT OF VISUAL "GRAMMAR"

When you use a ***compositional device***, think of it as a guide for forming an entire visual "sentence"—a statement within which you use ***visual elements*** and ***visual relationships***—to "say" what is important about a given topic.

Think of your finished artwork as a "statement" that captures your topic in a very specific way. Maybe the subject of your composition is a circus poster and you need a unique way to show the feeling of "circus." Or perhaps it's an instruction booklet and you need a cover that conveys what's inside. The eight ***compositional devices*** are tools to try out different types of visual statements or "sentences" about your subject.

Visual elements are like "nouns" and "adjectives." They are the "things" you select to use in your visual statement—along with different ways to visually describe or modify those things—much like the nouns and adjectives in ordinary language.

The ***visual relationships*** are like "verbs." You will use them to arrange and place the ***visual elements*** within whichever ***compositional device*** you decide to use.

Think about pauses in conversation (also in music). Pauses are important—they can be likened to the space between things in your composition—the quietness of empty space balancing the chattiness of filled-up space.

———

When you have gone through *The Design Code* lessons, reread this **Preface and Intro Section**, and it will hold new meaning for you.

Basic Visual Elements ◀ *SELECT*

These are the basic building materials of composition from which you can make selections.

- 3 Basic **Visual Descriptions** - line, plane, tone
- 4 Basic **Directions** - horizontal, diagonal, vertical, curve
- 3 Basic **Shapes** - square, circle, triangle
- 4 Basic **Surfaces** - reflective, opaque, translucent, transparent
- 3 Basic **Surface Enrichments** - color, pattern, texture

Basic Visual Relationships ◀ *RELATE*

Within a composition, use this basic set of guidelines to connect, arrange, and display the visual elements you have selected.

- 2 Basic **Balance Strategies** - symmetry, asymmetry
- 3 Basic **References** - location, direction, size
- 5 Basic **Connections** - point-connect, edge-to-edge, overlap, foreground/background interplay, eye path
- 5 Basic **Removals** - pop-out, reflect-out, over-out, slice-off, slide-out
- 5 Basic **Depth Cues** - scale, position, shadow (form or cast), foreshorten, focus

Basic Compositional Devices ◀ *COMPOSE*

These eight compositional devices are eight proven strategies (guides) in designing an overall composition. Choose only one for any given piece of art.

Except for "One Focal Point" and "Two Focal Points," with all other compositional devices, touch at least two edges or more with your compositional arrangement. Within any of these compositional devices (themes) you can play with your selection of visual elements and visual relationships to achieve whatever visual goal you wish.

- **One Focal Point** - free-float one *visual element* (or cluster) within a working space
- **Two Focal Points** - free-float two *visual elements* (or clusters) within a working space
- **Repeat** (*surface enrichments* work well with this device)
- **Negative/Positive** (*removals* work well within this device)
- **Frame**
- **Structure** (*connections* work well with this device)
- **Movement**
- **Perspective** (*depth cues* work well with this device)

Unexpected twists, unusual croppings, and juxtapositions can add interest. For more on this, refer to the ***Idea Generation*** section of this book.

An apple—the symbol of discovery and learning—is used to demonstrate concepts as you are introduced to *The Design Code* process.

An aside: As you read through the book, notice that italics are used to call your attention to various parts of *The Design Code*.

Each lesson begins on the left-hand page with a statement or question, followed by an explanation. Geometric forms illustrate the concept on the opposite page—and drawings of apples repeat the concept. This helps clarify and reinforce your learning.

The basic lessons are divided into three parts—The *Visual Elements*, the *Visual Relationships*, and the *Compositional Devices*. To easily locate where you are in *The Design Code* lessons, note the apple on the upper left side of the page that introduces each lesson. A light gray apple is used in the *visual elements* section. The middle gray apple in the *visual relationships* section, and the dark gray apple in the *compositional device* section.

The Design Code is not a linear thought process. It is a spherical thought process.

Picture yourself inside a sphere, selecting the parts of *The Design Code* that you might use on any given project. (It isn't necessary to become an expert on the entire *Design Code*—any more than it is to be an expert on all aspects of a computer and its apps. Just use the parts that are the most helpful to you, until you're ready to add more.) The lessons are sequential in learning, but not in practice. Any part of *The Design Code* can trigger an inspiration. I like to think of *The Design Code* as suspended in space, where I can see it all—and that I can just reach up and grab any part that I want to try out in my composition.

Following the basic lessons, there are additional sections on:
● How to **generate fresh ideas**;
● How to **modify shapes with three basic actions**;
● How to **portray change and the passing of time**;
● And, at the back of the book—**book reviews to help you grow as an artist** —**testimonials** and an **index**.

SELECT

PART ONE: VISUAL ELEMENTS

What are *Visual Elements?*

The ***Visual Elements*** are the basic ingredients or the basic building blocks of artistic composition. They include:

The 3 Basic Visual Descriptions

The 4 Basic Directions

The 3 Basic Shapes

The 4 Basic Surfaces

The 3 Basic Surface Enrichments

Everything else is a variation of these.

 How would you depict (visually describe) an apple using only black?
— You could use line, plane, or tone. See next page.

Line: If you use a *line* to describe the apple, a line would be threadlike and continuous. Then you would have some further choices to make. How thick or thin would that line be? Would the line stay the same thickness throughout the artwork, or would it vary? Would it be a simple outline, or would it show some detail? Would your lines cross over each other?

Plane: Perhaps instead you choose to describe the apple with a *plane*. (Planes are flat shapes that define an area.) Your apple shape would be all black or a single shade of black (single gray value) throughout. Then, how would the edges of your shape's silhouette appear—softly torn or precisely cut?

Tone: Or you might use *tone*—the gradated shades that charcoal drawings or pastels produce; or the various shades of grays in black and white photos. Will your tones softly blend or show sharp edge definition as they transition from light values to dark values or vice versa? In printing, sharp edge definition of the grays in a gradation are often referred to as banding (which can be good or bad depending on the desired effect.)

(Note: As you progress through the examples in this book, you may notice the apple drawings are mostly tonal. That is because they were pencil sketches—taken directly from my sketchbook, as I worked through *The Design Code*. However, the primary geometric examples are all sharply defined and computer-generated. When I do visual thinking, I like to use a pencil, but *The Design Code* applies to all media.).

Line, **Plane**, and **Tone** are the **Three Basic Visual Descriptions**.

3 Basic Visual Descriptions

LINE	PLANE	TONE

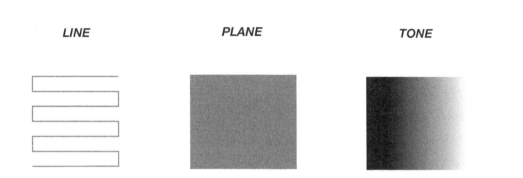

● *AND THEN THERE IS POINT—A CONCEPT, A LOCATION, A MARK, OR A DOT.*

A DOT CAN BE A STARTING POINT: FOR EXAMPLE, IMAGINE A LINE AS A POINT STRETCHED. IMAGINE A PLANE AS A POINT ENLARGED. OR, DOTS MULTIPLIED TOGETHER IN SUCH A WAY AS TO CREATE THE FEELING OF TONAL VARIATION.

TO CREATE TONE, THINK: SHADING, PHOTO, OR COMPUTER GRADIENT.
LINES OR PLANES CAN BE SOLID OR HAVE TONAL GRADATION.

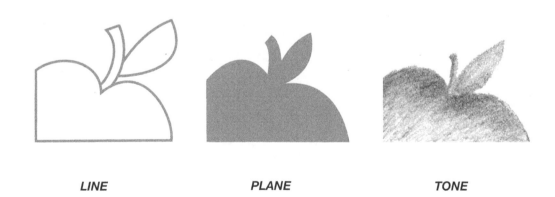

LINE	*PLANE*	*TONE*

13

How can you make an apple express direction?
Perhaps roll it horizontally? Toss it diagonally?
Drop it vertically? Throw a curve?

Would you teach it tricks like the apple core at the right?

Would you slice off a *horizontal, diagonal, vertical,* or *curved* chunk?

Would you slice pieces the same way, using a *horizontal* direction? How about using a *diagonal*, a *vertical,* or a *curved* direction?

Horizontal, **Diagonal**, **Vertical,** and **Curve** are the **Four Basic Directions**.

4 Basic Directions

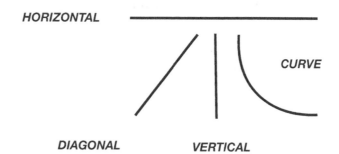

HORIZONTAL

CURVE

DIAGONAL

VERTICAL

DIRECTIONAL ROLE-PLAY

DIRECTIONAL EDGE APPLIED

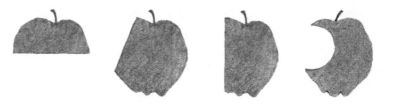

DIRECTIONAL GRID

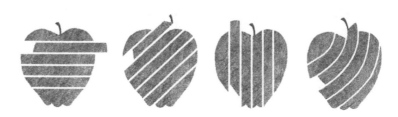

 Imagine a square apple. Then imagine it as perfectly round. Then imagine it in a triangular shape.

Squares: Perhaps you are a sculptor. Try sculpting an apple in the shape of a *cube*—which belongs to the *square* family.

Circles: Now sculpt it in the shape of a *sphere*—which belongs to the *circle* family.

Triangles: How about a *pyramid* or *cone*—which belong to the *triangle* family.

Other Shapes: Rectangles, pentagons, diamond kites, rhomboids, parallelograms, ovals, scalene triangles, octagons, stars, egg shapes, etc., are all variations on *squares*, *circles*, and *triangles*.

A *shape* conveys identity, whether representational or non-representational. You can make a *shape* with a *line*, or a *plane*, or a *tone*—or some combination of *line*, *plane*, and *tone*. A *shape* could consist of (be filled with) solid black, or a gray value, or one of the *surface enrichments* (*color*, *pattern*, or *texture*)—or a *shape* can be merely suggested (partially completed, but not entirely "realized.")

A *shape* could be cut out of a photo. A *shape* could also be the negative space (empty space) where the *shape* was removed from the photo. The empty space left behind would be clearly identifiable as the same *shape*, but with the positive part taken away—as happens with puzzle pieces.

Two-dimensional shapes are flat. Three-dimensional shapes have volume. The illusion of a three-dimensional shape can be created with shading.

Square, **Circle**, and **Triangle** are the **Three Basic Shapes**.

3 Basic Shapes

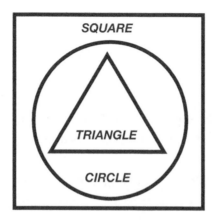

THESE SHAPES ARE THE BASIS FOR MORE COMPLEX SHAPES

THINK: EGGS, KITES, STARS OVALS, PENTAGONS, TRAPEZOIDS, ETC.

FLAT, TWO-DIMENSIONAL SHAPES

| SQUARE | CIRCLE | TRIANGLE |

THREE-DIMENSIONAL SHAPES

| CUBE | SPHERE | PYRAMID OR CONE |

 Have you seen a shiny silver apple? Have you seen a clear glass apple? How about a wood apple? Have you looked out the window at an apple orchard through a gauzy curtain?

Think about how light interacts with a surface.

Reflective: When light bounces off an object, such as an apple that has been polished to a high sheen, the surface is described as *reflective*.

Opaque: Put a paper label on a jar of apple sauce, and it will block the viewer's line of sight from seeing whatever is inside the jar, since the paper is an *opaque* surface.

Translucent: When early morning fog envelopes an orchard with layers of mist, light can only filter through, which affects how clearly you can see individual trees. The same thing happens when you lay a piece of tracing paper over a drawing. You can see the drawing, but not as clearly as if you had put a piece of clear plastic over it. The tracing paper and the mist would be referred to as *translucent*—something you can see through, but not clearly. There are many degrees of translucency.

Transparent: When you can see through a surface with clarity, such as a glass of clear apple juice, that surface is *transparent* (and the apple juice is, as well).

Reflective, **Opaque**, **Translucent**, and **Transparent** are the **Four Basic Surfaces**.

An aside: If you piled on enough layers of tracing paper, you would not be able to see through it and it would be considered *opaque*. There are also varying degrees of *reflection*—think of a polished apple that begins to gather dust.

4 Basic Surfaces

REFLECTIVE OPAQUE TRANSLUCENT TRANSPARENT

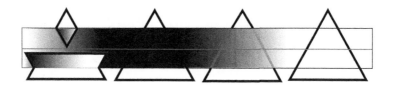

This is a diagram that requires some imagination. We are looking down on a wide band that has been folded in two with a tent-fold (the top of the fold is denoted by the thin line down the middle of the band). This folded band is straddling four triangles, which are laying flat. From the left, the surface of the band starts out reflective (mirror-like), then it slowly changes to opaque (no visibility through it), then to translucent (it can be seen through—but obscurely), then to transparent (it can be seen through clearly).

REFLECTIVE
(SHINY)

OPAQUE
(SOLID)

TRANSLUCENT
(SLIGHTLY OBSCURED)

TRANSPARENT
(CLEAR)

19

 What would make a surface more interesting? Could you add color? Could you add pattern? Could you add texture? Maybe add all three?

Color, pattern, and *texture* can be used to unify (group) or *enrich* surfaces.

Color: When working in black and white think of using different values of gray (shades of black) as imaginary "color."

Pattern: This is a recognizable repeat. A swarm of bees flying to the orchard in spring is a *dynamic pattern*. A photo of an apple tree shows a *random pattern* of apples growing among the leaves. A photo of the apple orchard shows a formal *static pattern* of tree rows.

Texture: This is an unrecognizable repeat. It can be like the visual dappling on the surface of an apple. Sometimes texture is both visual and tactile. You can both see and feel the roughness of bark on a tree.

Color, **Pattern**, and **Texture** are the ***Three Basic Surface Enrichments.***

An aside: A recognizable repeat of space between shapes can create a *pattern*—even when the shapes are different sizes and colors (consider mosaics).

3 Basic Surface Enrichments

COLOR

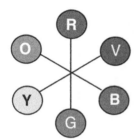

PATTERN

TEXTURE

COLOR

PATTERN

TEXTURE

VARIATIONS ON PATTERN

STATIC (FORMAL, STATIONARY)

DYNAMIC

RANDOM

Why are specific numbers associated with each part of *The Design Code?*

As Fred Griffin, developed *The Design Code* system, his goal was to reduce the visual components of picture-making to an absolute basic building-block level. Decades of classroom and professional exploration, resulted in the groups and numbers presented in these lessons. Those of us who were influenced by him are immensely grateful for his tireless pursuit to logically nail down the basics. We have used *The Design Code* in our professional careers to win awards for our clients and feel it gave us an edge when it came to idea generation. Read more about our praise for Griffin and his influence, in the testimonials at the back of the book.

Fred Griffin (1931-2011) developed *The Design Code* system.
For many years, he was a professional artist, and also core faculty member of The Burnley School of Professional Art, which was later purchased by The Art Institute of Seattle. He also taught at Cornish School of Allied Arts, Seattle—now Cornish College of the Arts.

Griffin's teaching career spanned 53 years. He started his exploration of logic in the arts, as a graduate of the University of Washington and Chouinard Art Institute—now California Institute of the Arts, in Los Angeles. It was his desire to create a system that would help professionals generate ideas on demand—a system they could use to grow themselves as artists. He was a member of the AIGA (American Institute of Graphic Arts) and the Graphic Artists Guild, and a recognized Northwest painter. If you'd like to enjoy his explorations, paintings and sketchbook art, go to: http://fredgriffinart.com The website was created to catalog his paintings and honor his legacy.

 RELATE

PART TWO: VISUAL RELATIONSHIPS

What are *Visual Relationships*?

The *Visual Relationships* are guides to help you arrange *Visual Elements* in relationship to each other and to the boundaries (edges) of your working-space. Change one thing in the working-space and all other relationships change. *The Design Code* helps artists understand the forces at play. The *Visual Relationships* are:

The 2 Basic Balance Strategies

The 3 Basic References

The 5 Basic Connections

The 5 Basic Removals

The 5 Basic Depth Cues

 Are you a person who likes everything to match? Then you will like symmetry in the arts. Are you a person who likes things that don't match? Then you will like asymmetry.

Symmetry: This is about formal balance—usually exact repetitions or even amounts. A checkered flag, or spokes of a wagon wheel, or a mirrored image are good examples.

Ways to achieve *symmetry* in composition: Slide an exact repeat of a shape sideways (this is also referred to as translation)—or flip it horizontally or vertically (also referred to as reflection)—or invert it, as card decks do with their royal cards (referred to as inversion). You could also rotate it around a center point like a kaleidoscope (referred to as radial *symmetry*).

Asymmetry: This is about informal balance—irregularity and difference. The concept of a ton of dry leaves compared with a ton of apples is a good example. There's a relationship, but it is not a visually equal one. An *asymmetrical* composition does not have the type of 50-50 balance expressed in a *symmetrical* composition, but it can still embody a feeling of completeness and harmony. It just does it in a different way. It is not without order, but it is without *symmetry*. *Asymmetry* is not chaos. An *asymmetrical balance strategy* could be as simple as a random dot (not centered) on a large white background. It would split up the white space in an uneven balance. A centered dot would balance the white space *symmetrically* (evenly).

Symmetrical and *asymmetrical* could also refer to an idea rather than a visual depiction. Consider a ping-pong ball sitting beside a golf ball. Their visual volume appears mostly *symmetrical*, but inside, their mass is *asymmetrical*—not the same.

Symmetry and **Asymmetry** are the **Two Basic Balance Strategies** you can use for a composition's overall arrangement—or as a help in planning *visual relationships* within it.

2 Basic Balance Strategies

SYMMETRY (left)
ASYMMETRY (right)

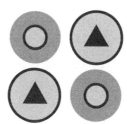 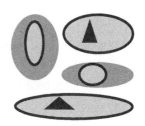

SYMMETRY

ASYMMETRY

DIFFERENT WAYS TO ACHIEVE SYMMETRY

SLIDE **FLIP** **INVERT** **ROTATE**

25

 Where is your favorite apple tree located? In a corner of an orchard or the middle? Do you pick its apples from above, with a ladder, or only its low-hanging fruit from the ground? Are its apples large or small?

The boundary edges of your working-space are like an orchard fence. They give a frame of *reference* for the *visual elements* within your composition. The positions of the *visual elements* (apple trees, people, vehicles, etc.) within the composition can be described as "in *reference*" to each other, or in *reference* to the orchard's boundary fence. Think of this as looking at a map.

Location: Wherever you (or something) happens to be *located*. That position can always be described as being in *reference* to something or someone.

Direction: If you point in a *direction*, you are directing attention to something —referring to it or making *reference* to it.

Size: To perceive the *size* of something, it is important to have a comparison —something to refer to—a *reference*.

Location, **Direction**, and **Size** are the **Three Basic References**.

An aside: When thinking about *size*, using a combination of large, medium, and small objects—or spaces—will add interest to your composition.

3 Basic References

LOCATION	**DIRECTION**	**SIZE**

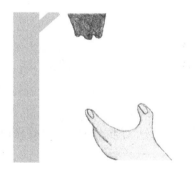
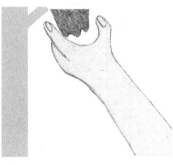

LOCATION
(of apple on tree)

DIRECTION
(of reach to pick it)

SIZE
(in relation to hand)

 Think of visual relationships (connections) as invisible glue—the ways in which your visual elements directly or indirectly relate to each other.

Point-Connect: This relationship connects shapes by meeting at a point or tangent (a point to an edge or a point to a point). These relationships can touch or almost touch.

Edge-to-Edge: This abuts an edge of a shape with an edge of another shape. It can touch or have a channel of space between the shapes.

Overlap: A simple *overlap* connection happens whenever you place a shape over another shape. You might overlap an opaque surface with a reflective transparent surface, or with a translucent surface, or with another opaque surface. [Fine point for purists: When overlapping with an *opaque* shape, the eye could interpret it as an *edge-to-edge connection* (since you can't actually "see" that something is underneath)—or if the opaque shape is the same color as what it overlaps, the eye might interpret it as "merged"—as a whole, and not as an *overlap*.]

Foreground/Background Interplay: Think of images in your composition as filled-up space—the foreground (positive) part of the composition. Think of the empty space around images as the background (negative part) of the composition. The combined positive and negative space is often referred to as having a "figure/ground" relationship. In composition, the empty spaces are as important as the filled-up spaces. Notice the "empty" space that looks like a tree framed by two apples (lower left, next page). The two apples are held together by the shared empty space between them that suggests a tree. Call this relationship *foreground/background interplay*. This connected relationship is like a ghost. It suggests something is there that is not. You may have been concentrating on the positive shapes in the foreground and suddenly became aware of the tree suggested by the empty space. This phenomenon is responsible for optical illusions.

Eye Path: Imagine jumping from rock to rock to cross a stream that runs though your apple orchard. Your jumps follow a path. In that same way, within a composition, your eye can be led to jump from shape to shape along invisible paths. Call those types of phenomena *eye path* (this is often referred to as contour continuation).

Point-Connect, Edge-to-Edge, Overlap, Foreground/Background Interplay, and **Eye Path** are **The Five Basic Connections** (ways to relate things).

5 Basic Connections

POINT-CONNECT

(touch or almost touch)

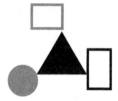

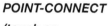

OVERLAP

(opaque or translucent)

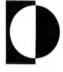

EYE PATH

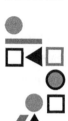

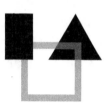

EDGE-TO-EDGE

(touch or almost touch)

FOREGROUND/ BACKGROUND INTERPLAY

POINT-CONNECT

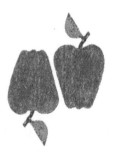

EDGE-TO-EDGE

OVERLAP

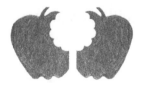

FOREGROUND/BACKGROUND INTERPLAY

EYE PATH

 Removals are a subset of the basic connection of foreground/background interplay. You may choose to retain a "removed piece" and make it part of the final composition or discard it.

If your choice is to keep the "removed" piece of a shape, then you can use it somewhere else in your composition.

Pop-out: Punch a hole in a paper shaped like a leaf. Include the leaf and the punched out piece as part of your composition. Anyone looking at the composition will see a relationship between the hole and the punched out piece. They will understand that the punched out piece has come from the leaf. Call that removal action *pop-out*.

Reflect-out: Cut a hand shape out of a paper apple and swing the hand out in a hinged manner. The empty space it leaves behind tells the viewer that the hand shape came from that missing space in the apple. Call that type of removal *reflect-out*.

Over-out: Lay a black paper worm on a black paper apple. Cut out the intersection of both shapes where the worm overlaps the apple. Call this removal action *over-out*.

Slice-off: Slice through a paper tree and move the sliced part away. Call that type of removal action *slice-off*.

Slide-out: With a drawer-like movement, pull a black paper apple core out of a black paper apple. Call that *removal* action *slide-out*.

Pop-Out, Reflect-Out, Over-Out, Slice-Off, and **Slide-Out** are **The Five Basic Removals.**

5 Basic Removals

POP-OUT **REFLECT-OUT** **OVER-OUT** **SLICE-OFF** **SLIDE-OUT**

 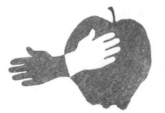

POP-OUT **OVER-OUT**

REFLECT-OUT

SLICE-OFF **SLIDE-OUT**

31

 Linear perspective is not for everyone. So, here are some tips on depth perception to create perspective in five different ways. Some might think of this as "fake" perspective.

Scale: Assume things are the same size. Things larger appear closer to the viewer.

Position: Things closer to the viewer overlap things further away.

Shadow: Soft shadows and hard shadows can be used to show form and distance. Form shadows help define an object's identity; cast shadows show distance. The nature of a shadow depends on the angle and intensity of the light source that creates it.

Foreshortening: A viewing position can distort and exaggerate shape. Notice that the apple core drawing on the next page (lower left example) is *foreshortened* (which means we see closer parts as larger.) Also, in the geometric examples on the upper part of the page (second group from right), notice the *foreshortening* effect that happens when a viewer walks by a wall and observes it from three different viewpoints—how its shape distorts.

Focus: Think about fog, how things nearer are easy to identify and have sharp focus, while things that recede into the distance lose their clarity and become more diffused.

Scale, Position, Shadow, Foreshorten, and **Focus** are **The Five Basic Depth Cues**. Any of these effects can bring a feeling of spatial depth to a composition.

5 Basic Depth Cues

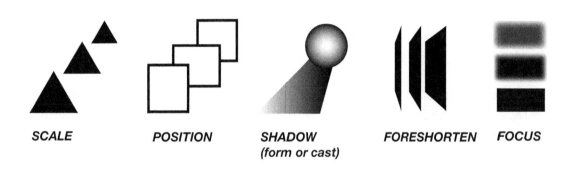

SCALE **POSITION** **SHADOW**
(form or cast) **FORESHORTEN** **FOCUS**

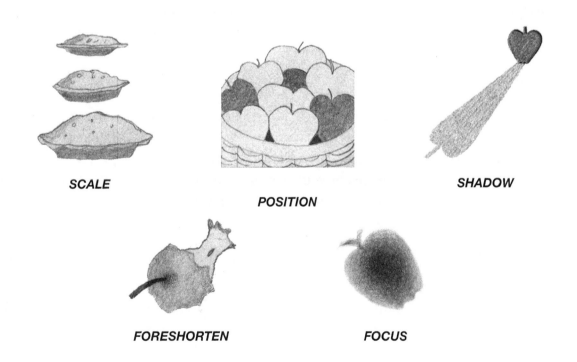

SCALE

POSITION

SHADOW

FORESHORTEN

FOCUS

33

MEET THE BACKBONE OF *THE DESIGN CODE* SYSTEM
—*THE EIGHT COMPOSITIONAL DEVICES*

These are *The Design Code*'s eight archetypes of overall picture-building strategy—eight key approaches for you to choose from, when you stare at a blank canvas. Plus a matrix chart with even more possibilities!

WHY EIGHT?

They are Griffin's selected palette of eight dominant ideas—eight ways to jump-start your imagination. Through many experiments with design principles in the classroom and in his personal art, Griffin refined these eight picture-building strategies to help answer the question, "What to do with a blank canvas?"

If you were a chef, you might think of the eight *compositional devices* as eight different ways to prepare something. Suppose you've been asked to bring something that involves apples to a potluck. In the past, you have experimented with how to prepare apples and came up with eight proven recipes—all different—among them, an apple pie, applesauce, caramel apples, a Waldorf salad, etc. Which apple dish will you choose to bring to the potluck? And once you choose that recipe, there are many possible variations when adding ingredients and spices. Now, liken that recipe to a *compositional device*. It is the same—once you select a *compositional device*, there are many variations that can be achieved, as you add *visual elements* and *visual relationships*.

The *compositional devices* are guidelines (ideals), not authoritarian rules. The first—*One Focal Point*, attracts attention. The second—*Two Focal Points*, can match or compare things. (All *visual elements* used in either of these two *compositional devices* will float well free of any edge.) The *visual elements* you use in the other six *devices*—*Repeat*, *Negative/Positive*, *Frame*, *Structure*, *Movement*, and *Perspective*—will have *visual relationships* to the edges of your working-surface. Your choice of *balance strategy* for any of these *compositional devices* can be *asymmetrical* or *symmetrical*.

On page 50, is a matrix chart that shows how these eight compositional approaches can modify each other to generate 64 possible ideas. The matrix suggests how to modify a primary *compositional device* (shown along the side), with a secondary influence from a different *compositional device* (shown on the top row). Across from that matrix, is an example which uses the *compositional device, Repeat*, to show how it works. (A primary group of *repeated* basic shapes is influenced by all eight *compositional devices*.)

▶ COMPOSE

PART THREE: COMPOSITIONAL DEVICES

What are the Compositional Devices?

Now that you have worked through *Visual Elements* and *Visual Relationships,* it's time to put them all together in a composition.

To better understand how *Compositional Devices* fit into the overall scheme of things, please look again at the chart on page 9. Remember to think of *Compositional Devices* as complete visual sentences (statements), made with your choice of *Visual Elements* and *Visual Relationships*. The eight basic *Compositional Devices*, listed below, are like dominant ideas (suggested themes)—proven ways to compose a picture:

● *One Focal Point* ● *Two Focal Points*	In these two *Compositional Devices,* all elements float well free of the edges.
● *Repeat* ● *Negative/Positive* ● *Frame* ● *Structure* ● *Movement* ● *Perspective*	These six *Compositional Devices* give the working space a sense of unity by elements touching two or more edges (or almost touching edges).

One Focal Point: If this *compositional device* were likened to a sentence, it would shout: *"Look at this!"* This device is all about attention focused on one spot—one dominant object or area. For instance, on the next page, the upper right box features an apple as its sole performer. (Showing a cluster of grapes, instead of an individual apple would have worked as well, since the observer perceives a cluster as a single object. You could also use a cluster of letters— such as a single word or a quote.)

A tip for working with One Focal Point: *Symmetrical* balance would be a perfectly centered apple, while using an *asymmetrical* balance would be an apple that is off-center—as in the example.

Two Focal Points: If this *compositional device* were likened to a sentence, it would say: *"Look at this—and look at that!"* With this device, tension comes into play. An observer wants to know why those two shapes are shown— what's their relationship? If you were to use a cluster of grapes, you could show a fallen grape by separating one grape from the cluster. Or use letters to tell a story of conflict—for instance the word "Yes" floating on one side of the composition and "No" on the other. With two focal points there can be a sense of competition like a tortoise and a hare; or a sense of comparison, like identical twins or fraternal twins; or the unequal balance seen in the volume of a pound of cotton contrasted with that of a pound of rock; or the tension of resolution—as with the arrow approaching the apple (lower right box).

A tip for working with One and Two Focal Points: Think about the three basic *references—location, direction, size*. What is a shape's location (position) in the working-space? Is it located toward the top, bottom, side, or at the center? Will you show the *shape* upright, upside down, or leaning in a direction? Will it be large, medium, or small?

[*Note:* A specific requirement for *One Focal Point* and *Two Focal Point compositional devices* is: *Visual elements* float well free from any edge—attention is then directed to either a singular object—or the relationship of objects to each other—and does not suggest a strong magnetic attraction to any edge.]

One Focal Point

FLOAT FREE FROM EDGES

A single spot of attention: can be one shape or a cluster.

THINK: dominating, commanding.

Two Focal Points

FLOAT FREE FROM EDGES

Two spots of attention: can be two shapes; two small clusters; or a shape and a small cluster (keep the two spots of attention separate from each other).

THINK: contrast, comparison, or commentary. It could be a shape with accompanying words that give meaning— like a photo and caption used in a creative way.

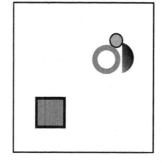

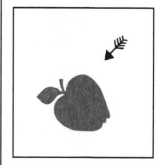

Repeat: If this *compositional device* were likened to a sentence, it would say: *"See how I multiply and echo shapes."* A good rule of thumb for this compositional device is to repeat something at least three times and then the viewer will know you meant it. You can repeat as many shapes as will fit into your working-space—or as few as three. *Pattern* is one type of *repeat*. An echoed edge or repeated space is another. Camouflage relies on repetition of *texture, pattern,* or *color*. Repetition is all around us—it's part of our daily experience.

A tip for working with Repeat: Use the three basic *surface enrichments,* especially *pattern*. In keeping with the dominant theme of *Repeat*, be careful not to emphasize that one shape is closer than another to the viewer. That could suggest that the compositional idea you are using is *Perspective* and not *Repeat*—which is an entirely different thought! *Repeat* can also be used in the spaces between.

[*Note:* With the exception of *One Focal Point* and *Two Focal Points*, the arrangements used in all other *compositional devices* are required to touch (or almost touch) two or more edges of the working-space. In the printing industry when printed shapes touch the edge of the paper it is referred to as "bleed."]

Negative/Positive: If this *compositional device* were likened to a sentence, it would say: *"I am actually the whole composition because I am the foreground and background space interplaying with each other."* *Negative-positive* space can be a Zen concept [filled up space/empty space]. Consider the following:
 (1) A musician relies on pauses and notes to create music, not just the notes.
 (2) People who buy drills, don't buy drills, they buy holes.
 (3) The old adage: "Is the glass half empty or half full?" (both)
 (4) Schools use blackboards and white boards.
 (5) Puzzle pieces are about empty space and filled up space.

Negative/Positive, as a *compositional device,* can be a sudden perception reversal—an unexpected change of foreground focus for background focus, which is the basis of many optical illusions. In thinking about sculpture, concave and convex are *Negative/Positive* concepts—opposites.

A tip for working with Negative/Positive: Use the five basic *removals (*page 30 and 31*)* and *foreground/background interplay (*page 28 and 29*).*

Repeat

TOUCH TWO EDGES OR MORE

Echo a shape, a shape's edge, a characteristic, a surface, or a surface enrichment.

THINK: repeat—static, dynamic, or random pattern—there can be lots of focal points; also, consider the repeated channels of space in mosaics.

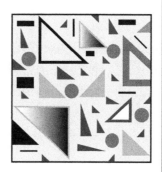

Negative/Positive

TOUCH TWO EDGES OR MORE

Use Basic Removals

Optical illusions can be created by figure/ground ambiguity (unexpected foreground/background exchange).

THINK: interplay of foreground and background; convex/concave; occupied space/empty space; present/absent; in/out.

39

 Frame: If this *compositional device* were likened to a sentence, it would say: *"What a great picture this is."* *Frame* is about enclosures or partial enclosures. *Frames* can appear as borders, spirals, or brackets. They can be rectangular, circular, U-shaped, V-shaped, etc. *Frames* can surround things partially or fully. Cropping a photo *frames* a view. Also a *frame* can be a container that protects—think of eggshells—or a container that restricts—think of a cage. Apples are *framed* (embraced) by their crate. In the example "apple of my eye" (next page, upper right box*)*, the eye is *framed* by the eyebrow.

[*Note:* With the exception of *One Focal Point* and *Two Focal Points*, the arrangements used in all other *compositional devices* should touch (or almost touch) two or more edges of the working-space.]

 Structure: If this *compositional device* were likened to a sentence, it would say: *"I am the architect of the page."* *Structure* is about organization and building. It's about division of space. It's about visible and invisible forces that hold things together. It's also about grids. Think of the grid-style artwork of Dutch painter, Piet Mondrian. Think of the divisions in bookshelves and storage cupboards. If you use a visible grid to place *visual elements,* your composition will look highly organized. If you remove the grid from around the *visual elements*, it will look like invisible glue is holding everything together. On the other hand, if instead of using a grid for placing your *visual elements*, you use some or all of the five basic *connections* to organize your *visual elements*, they will automatically create the look of an invisible grid.

A tip for working with Structure: Make use of *asymmetry or symmetry.* Think about small, medium, and large objects and spaces. Think about *vertical* and *horizontal* space divisions, although *curve* and *diagonal* also work.

Frame

TOUCH TWO EDGES OR MORE

Circular, triangular, or rectangular frame.

Use a border, a spiral, brackets, a U-shape, or a V-shape.

THINK: contents in a bowl, a peek-hole, a view framed by tree branches.

Structure

TOUCH TWO EDGES OR MORE

Division of space; visible or invisible grids.

Use basic line directions with a horizontal and vertical emphasis.

THINK: large, medium, small.

 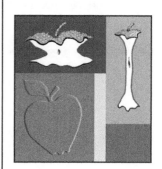

41

Movement: If this *compositional device* were likened to a sentence, it would say: *"This is exciting!"* *Movement* is about energy, sequence, rhythm, lyrical flows, or time. It conveys the idea of change. Change can be from sudden to gradual. Think of: A wet dog shaking off water; or cartoon energy lines that suggest movement or agitation; or a journey; or a transformation; or music.

A tip for working with Movement: To create the feeling of movement, use zigzags, swoops, smears, and after-images (as when a photograph captures time-lapse movement). Meandering paths and curves, such as the tracks of an animal or ripples in water can also suggest movement. A short or long story told in progressive comic book frames implies a movement of time.

Perspective: If this *compositional device* were a sentence, it would say: *"Look at this dramatic viewpoint."* *Perspective* is about different viewpoints, and distances. Imagine a bird's *perspective*, a mouse's *perspective*, a fish-eye *perspective*, a telescope's *perspective*, a microscope's *perspective*. Heightened interest in a composition can be manipulated through well chosen close-up views, mid-views, or far-views. (Several kinds of linear perspective are available for you to use, but they are not covered in this book. Linear perspective, like color, is an area of study unto itself.)

A tip for working with Perspective: Use the five basic *depth cues (page 32 and 33)*.

Movement

TOUCH TWO EDGES OR MORE

Curve or Diagonal emphasis.

THINK: swoop, meander, zig-zag, after-image, smear, scribble, storyboard, metamorphosis.

Perspective

 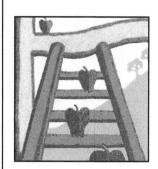

TOUCH TWO EDGES OR MORE

Use depth cues or linear perspective.

THINK: close-up, mid-shot, far-shot; birds-eye, mouse-eye.

A Quick Visual Review of the Eight *Compositional Devices*— First Using Geometric Forms and Then Using the Apple.

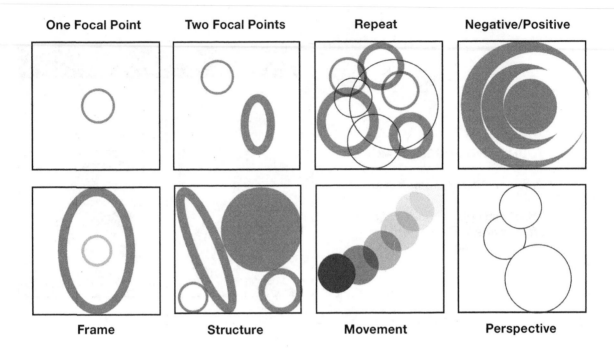

One Focal Point	Two Focal Points	Repeat	Negative/Positive
Frame	Structure	Movement	Perspective

In your sketchbook, pick random topics to use with the eight *compositional devices* (such as my apple example, below). That's a good way to gain facility with *The Design Code*—much like practicing a musical instrument brings competence.

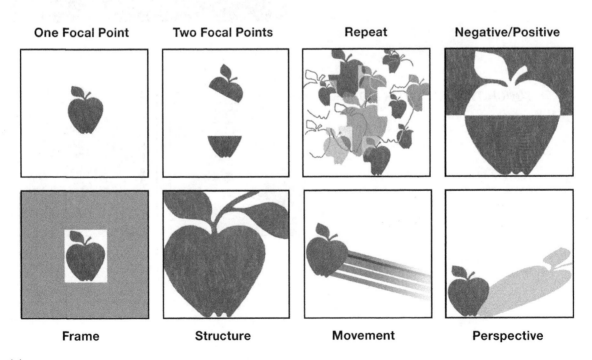

One Focal Point	Two Focal Points	Repeat	Negative/Positive
Frame	Structure	Movement	Perspective

BEYOND THE DESIGN CODE

IDEA GENERATION

Style, Tool, and Idea Spark

The Matrix of 64

Triangulation

Branching

"Dare to be bad . . . and do it often!" These words of wisdom given to a drama class were meant to free the actors from the pressure to be perfect. It's the same with the visual arts. Keeping a sketchbook helps an artist grow. Be sure to regularly draw, paint, and paste things into your sketchbook. If you are tempted to rip out a page— don't. Hold onto that page for another day. It may inspire a whole new twist after you've given it a rest. If you get one good piece of art out of five attempts, count that sketchbook session (or computer session) a success!

To begin a sketchbook page, start by picking a subject that interests you—such as animals or sports. Use that subject to explore ideas in *The Design Code,* just as you've seen it done here with the apple. If you tire of a given subject, pick another. If something isn't working, try exploring a different part of *The Design Code.* It's helpful to set a timer for ten minute sessions. Something with potential is bound to emerge. Originality comes from imagination and play. The more ideas you have, the more opportunities there are for unique solutions. Try ideas in which your subject is:

Representational *Semi-Stylized* *Highly Stylized* *Non-representational*

Think of representational art as realistic. Think of non-representational art as abstract. Think of stylized as somewhere in between. A non-representational approach can break things apart and relate shapes in new and different ways.

The checklists at the right are guides to help you experiment with many other ideas. Think about the possibilities of *style*—what about doing a cartoon, or using a symbol or silhouette? Or how about an idea coming from the *tool* you use—perhaps drawing an elegant ink line, using an emboss, or taking a photo. The *Idea Spark* list (next page at the bottom) gives you additional things to consider as you reach out for new ideas.

Approaches — Some Possibilities

Style

* ABSTRACT
* REALISTIC
* STYLIZED
* CARTOON
* SYMBOL
* LETTERING
* PAPER CUT-OUT
* PHOTO
* A MONTAGE ASSEMBLY
* 3-D RENDERING
* HISTORICAL PERIOD

Tool

* DRY MEDIUM
* WET MEDIUM
* SURFACE TEXTURE
* BRUSHES
* PENS
* PENCILS
* OILS
* LINOLEUM PRINT
* DIGITAL FILTER EFFECT
* PHOTO
* SCULPTED OR CARVED LOOK

Idea Spark

* ASSOCIATE
* COMBINE
* CONTRAST
* ELIMINATE
* MAGNIFY
* MINIFY
* REVERSE
* SUBSTITUTE
* BORROW
* CHANGE AMOUNT
* CHANGE QUALITY
* CHANGE PLACE
* NEW USE
* NEW VIEWPOINT
* NEW CROP
* VARIATION ON A THEME
* VISUAL PUN

* *Fluid Ink Line Drawing Courtesy of Anita Griffin*
Crab Apple Visual Pun Courtesy of Fred Griffin

The *Idea Spark* checklist can help you generate ideas with unique twists. For instance—in staying with the apple theme—think about the idea spark of "substitute." You might substitute the mathematical symbol of "pi" for pie in apple pie. With the idea sparks of "visual pun" and "combine" you could mix a crab and an apple for crab apple. The idea spark of "reverse" might suggest reversing the stem end on an apple. With the idea spark of "associate" (still using the apple theme), you might work with images of William Tell, Johnny Appleseed, or the snake from Adam and Eve.

These checklists are meant to stimulate the imagination. *The Design Code* gives you the basic *visual elements*, *visual relationships*, and *compositional devices* to work with. This *Idea Generation* section of the book gives you added idea power to use with *The Design Code*.

Some Further Thoughts on Styles and Tools

Individual style can be simple or complex, fluid or mechanical. Your tools can bring a soft-edged or hard-edged feel to your composition. They can also create a fluid (hand-done organic quality) or a mechanical look.

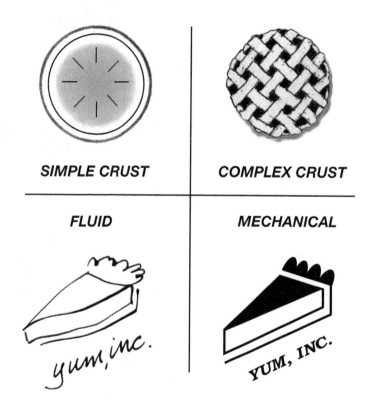

SIMPLE CRUST	**COMPLEX CRUST**
FLUID	**MECHANICAL**

Everything Should Be Thought of As Relative—As If on a Sliding Scale.

■ **Consider *Viewpoints:*** To a worm, an apple is a huge boulder of food. To a high-flying bird, an apple is a pebble of appetite on the horizon. To a human, an apple is a rock-sized meal in-hand.

■ **Consider *Metamorphoses*:** If you round the edges of a *square* enough, it becomes a *circle*. If you flatten a *circle* on three sides enough it becomes a *triangle*.

■ **Consider *Transitions:*** Polish a dull apple enough and it becomes *reflective*. Put the *opaque* flesh of an apple through a cider press and it becomes *translucent* apple juice. Strain *translucent* apple juice enough and it becomes *transparent* apple juice.

■ **Consider Different Balances of *Order* and *Interest*:** Remember the checkerboard and the scribble (see page 7)—how you can bring *interest* to the checkerboard by scribbling on a square, and a sense of order to the scribble by drawing a box around it.

The compositional strategies of *symmetry* and *asymmetry* are important influences pertaining to the balance of a composition. *Symmetry* is strictly about order, control, and equal balance—like the formal and static 50-50 balance of a checkerboard.

An *asymmetrical* strategy could range all over the place on a sliding scale. An *asymmetrical* composition might be 90 percent expressive, with just a small dab of *order* holding it together—like a box that corrals the scribble. Other times an *asymmetrical* composition might be 90 percent *order* with a small area of *interest* to liven it up, like a checkerboard with one scribbled square. *Asymmetrical* compositions can be any percentage of order and interest other than a 50-50 balance.

I often think of an emphatic pronouncement that a former fine arts professor and friend was fond of making—*"Contrast is everything!"*

The choices you make in a composition will govern its feeling of balance. Are control and order reigning or are excitement and expressiveness the main forces? There is not a "correct" creative strategy to follow, but playing with different amounts of *order* and *interest* will increase or decrease the contrast.

—How to Generate 64 Different Approaches to Composition!

In addition to using each *compositional device* alone, you can use them as influences (filters or modifiers) on each other.

Build a simple parameter chart (matrix) with the eight *compositional devices* listed down one side, and then again list them across the top, as shown below. Note the *compositional devices* listed down the side are in all caps. This indicates they have dominant/primary status. The *compositional devices* listed across the top are in lowercase to indicate they have secondary status. Their job is to "influence" the devices in the primary group along the left side. (In computer terminology, influence, would mean applying an app or filter to an image to change it in some way.)

Asterisks on the chart below show how a secondary *compositional device* can come together with a primary *device* to influence it. On the next page, this is illustrated with the *compositional device* of **Repeat**. In those examples, *Repeat* is influenced by each secondary *compositional device*. (*Repeat* is shown in all caps, as the common denominator or primary *device*, while each influencing *compositional device* is shown in caps and lowercase in the numerator position.) Try all 64 possibilities!

	one	two	repeat	neg/ pos	frame	struct.	persp.	move.
ONE								
TWO								
REPEAT	*	*	*	*	*	*	*	*
NEG/ POS								
FRAME								
STRUCT.								
PERSP.								
MOVE.								

You can decide whether to exert a big influence or a small influence with the secondary *compositional device*—the choice is yours.

Example: *REPEAT* Modified By Secondary Influences

A demonstration of the *Compositional Device* of *REPEAT*, influenced by all eight *Compositional Devices* (including itself).

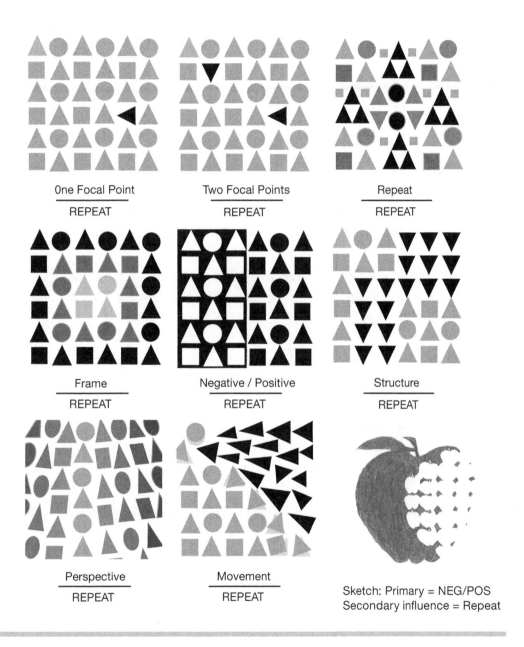

One Focal Point	Two Focal Points	Repeat
REPEAT	REPEAT	REPEAT
Frame	Negative / Positive	Structure
REPEAT	REPEAT	REPEAT
Perspective	Movement	Sketch: Primary = NEG/POS
REPEAT	REPEAT	Secondary influence = Repeat

The apple sketch (bottom right) uses ***Negative/Positive*** as the primary *Compositional Device,* and this time, ***Repeat*** is used as a secondary compositional influence.

Some Further Play with Compositional Devices

Try this *cumulative* progression.

Start with a pie crust (or you could choose a different subject, entirely).

Step one: Add the word **Apple** as an ingredient. (This demonstrates *One Focal Point* as a *compositional device*. It floats free from edges.)

Step two: Add the word **Pie** as a second ingredient. (**Apple** and **Pie** now demonstrate the *compositional device*, *Two Focal Points,* and float free from edges.)

Step three: Add more of both. (This demonstrates *Repeat* as a *compositional device*. At least two or more elements touch, or almost touch, the edge of the pie.)

Step four: It has now been baked and sliced. (Note that the crust's crimped edge borders the pie. Both it and the slice lines demonstrate *Frame* as a *compositional device*).

Step five: Remove a piece. (This uses *Negative/Positive* as a *compositional device*. It is achieved by the *removal* relationship of *slide-out,* in which the background and foreground begin to *interplay*.

Step six: Assemble all the pieces in a different order than the original pie shape. (This demonstrates using *Structure* as a *compositional device*.)

Step seven: The pie pieces begin to take on a life of their own as they move out of the assemblage. (This demonstrates *Movement* as a *compositional device*. In this case, an after image is used to achieve the effect of motion.)

Step eight: The pie pieces take flight into space. (This demonstrates *Perspective* as a *compositional device*—by using the *depth cues* of *scale* and *foreshorten*. Knowing the pie pieces are the same size—the viewer, intuitively relying on *scale*, will perceive that larger pie pieces are closer; and, simultaneously, relying on instincts regarding *foreshorten,* the viewer will know that the pieces dramatically distort as they travel away.)

Note: If this seems a bit complex—not to worry. As you become more familiar with *The Design Code*, you'll want to stretch your visual muscles. What other topics might lend themselves to a similar cumulative progression? This is a good thinking exercise for visual logic. I liken *The Design Code* to an elegant game of solitaire.

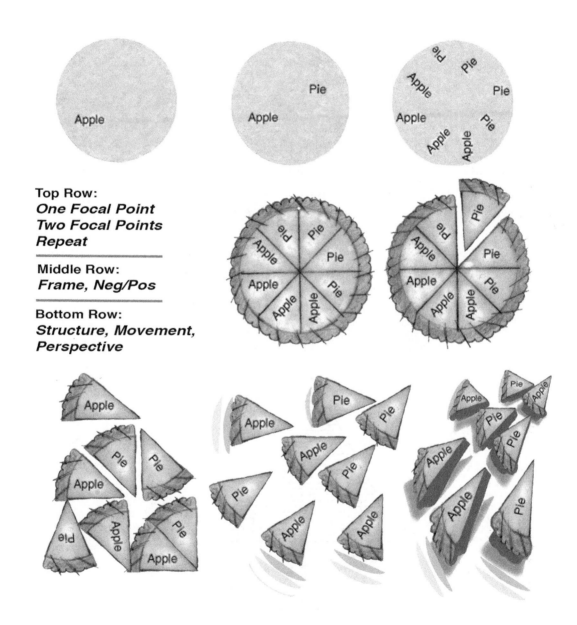

Top Row:
One Focal Point
Two Focal Points
Repeat

Middle Row:
Frame, Neg/Pos

Bottom Row:
Structure, Movement,
Perspective

Once you settle on a subject to visually explore. Here is help to get started.

In the large triangular model, below, are seven possible ways to use the ***three basic visual descriptions***: ***line***, ***plane***, and ***tone***, in a composition. (You can use these *visual descriptions* separately or in combination.)

The three largest triangles have these variations: ***1***—use only *line* in a given composition; ***2***—use only *plane*; ***3***—use only *tone*. In the next inner group of three upside-down triangles, each shares an edge with two larger triangles and creates a mix of them: ***4***—combine ***plane*** and ***line***; ***5***—combine ***plane*** and ***tone***; ***6***—combine ***line*** and ***tone***. The right-side-up triangle in the center shows a mixture of all three large triangles. ***7***—use all three of the visual descriptions, ***line***, ***plane***, and ***tone***, in one composition.

As you become accustomed to using *The Design Code* you will think like an orchestra conductor. Each part of *The Code* is like an instrument or groups of instruments to weave and combine.

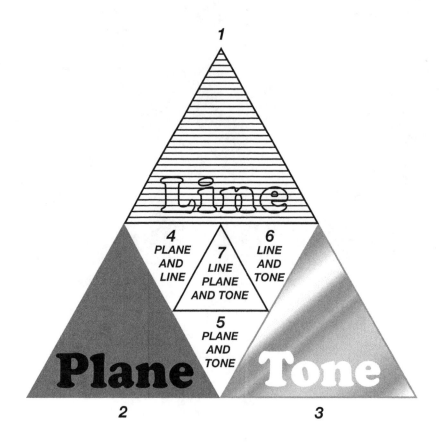

The diagram below is an idea-generating tool. It shows the main idea of *apple* and the categories and subcategories associated with it (dotted lines show cross-related topics). This is list-making in visual form. Good research generates lots of ideas that can result in better solutions. Doing this type of research chart helps you see the whole situation at once—how ideas and things relate. It's basically a brainstorming session with yourself, in which you associate ideas with a source. An intermediate idea can unite other topics—see the white box with the gray line border.

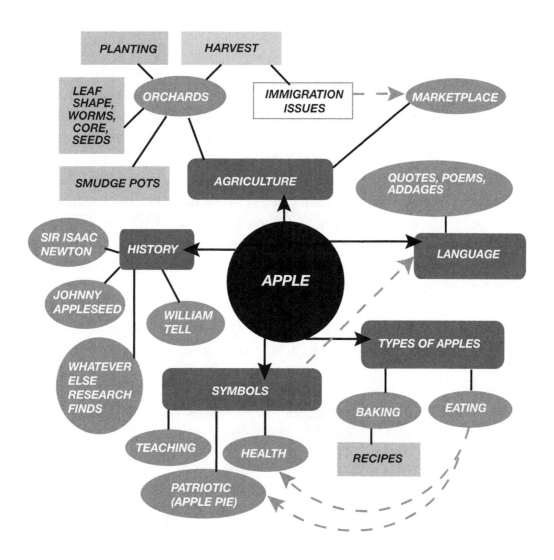

Key: Main Idea / First Level Ideas / Second Level Ideas / Third Level Ideas

Putting Things Together in My Sketchbook

The explanatory illustrations in this book have all used an apple theme. One idea associated with an apple is the Garden of Eden. So, as I thought about that subject, I explored different visual scenarios. I started with the checklists in the *Idea Spark* pages (found in the *Idea Generation* section, and also used *Branching*—an especially helpful tool to explore possibilities. After playing around with some ideas in my sketchbook, I came up with the illustration, below, and then decided to make it a painting (see back cover for color version). Here's an analysis of the contributing design thoughts.

The dominant *compositional device* is **Frame**, which I consciously used to introduce the snake. You will also see a secondary influence —the *compositional device*, **Repeat**—as seen in multiple trees; in the informal *pattern* of the apples; and, in the orderly *pattern* of the snake's skin. The rest of the painting—the choice of *visual elements* and *visual relationships*—was intuitive. To improve upon the initial idea, I gave it a twist—I made the apple tree hard to reach and gave Eve a ladder. A corporate colleague gave it added meaning by likening the illustration to climbing the corporate ladder! (Here's more analysis; *Vertical direction* is seen in the tree trunks; *horizontal direction* in the horizon line; *diagonal direction* in the snake's tongue, the ladder, and the snake's *pattern*); *curved direction* for the edges of the tree tops and the snake's body; *tone* is used in the tree tops; the area occupied by grass texture started out a *plane* (I added the grass texture to it); tall, medium, and short trees give *interest* and the similar empty spaces between tree trunks contribute to a feeling of *order;* and, I *located* Adam and Eve at the bottom of the garden.)

I encourage you to creatively plunge into an idea and explore it. And think about different parts of *The Design Code*—like yeast, any part can be an idea starter. Have fun trying things!

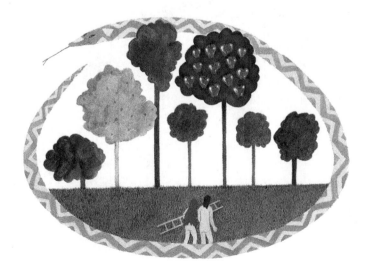

THE "DO-TOs" AND THE SEQUENCES OF CHANGE

How movement and change are portrayed in graphic novels, comics, and animation, fascinated Fred Griffin. Over the years, he analyzed and classified his insights. Think of this section as an extension of *The Design Code.* In it, I will share those observations.

Use change, time, and movement to tell visual stories.

Try these *"Do-To"* actions to bring new meaning to shapes.

The 3 *"Do-To" actions are:* —**Add** *(to a shape's edge)*
—**Interrupt** *(take away from it)*
—**Insert** *(put something inside it)*

Use *SEQUENCES OF CHANGE* to portray different types of change:

The 3 <u>LINKS</u> OF CHANGE: —*Apart*
[*Links* are about a change in proximity] —*Touch*
—*Blend*

The 3 <u>CATEGORIES</u> OF CHANGE: —*Change of Amount*
[*Categories* are about general change] —*Change of Quality*
—*Change of Place*

The 3 <u>METHODS</u> OF CHANGE: —*Spatial Depth*
[*Methods* are about specific ways to move] —*Figure/Ground Exchange*
—*Planar Shift*

[**A Quick Example:** You are doing a comic book about the Blue Angels. In your frame-to-frame action, you might increase the number of planes (that would be *change of amount*). Your viewer would see different perspectives of the planes as they do daring maneuvers (that would be changes in *spatial depth*—as they change positions in space.) The planes might attempt to touch wings (that would be a change of physical proximity—from *apart* to *touch*.) And from a distance, the planes might look like they merge—*blend* into a single unit). Changes brings interest to your composition. The more you know about change, the more you can control it. Read on!] 57

CHANGES IN SHAPE: USE `THE 3 "DO-TOs"` TO MODIFY SHAPES

- **Add** *(onto the edge of a shape)*

- **Interrupt** *(take away from the edge of a shape; or pierce through it)*

- **Insert** *(put something inside a shape)*

Note: For learning purposes, think of the apple examples as paper cutouts (however, they are actually pencil drawings from my sketchbook).

ADD Both of the geometric examples, below, work for **add**—in which a shape is added to another shape. However, the example on the right is slightly different, since it maintains a small channel of space between the two shapes.

The sequential sketches, below, show the interaction of two images coming together (an arrow and apple)—as they perform the *DO-TO* action of *add*. Again, envision this as a black paper cutout (or as a shadow show on a wall). In this small story, the arrow shaft is added to the apple silhouette. It changes the image of the apple by "adding" to its contour—its silhouette. Note that the last apple on the right shows a very thin channel of white space that separates the apple and the arrow shaft. It's okay to do that. (Visually, it's perceived as a whole.) You have now *added* to the shape.

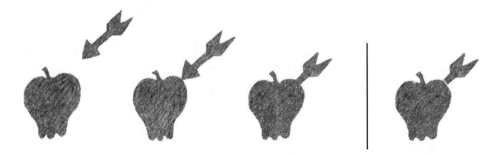

Exercise 1: Pick a topic and tell a small visual story (in three steps) that shows a shape being *added* to.

[***Tip for Add:*** As you *add* on to an image, the ***visual relationships*** of *point-connect* and *edge-to-edge* are helpful to consider (see page 29).]

INTERRUPT Both of these geometric examples work for ***interrupt***. One type of *interrupt* effects the edge, the other type of *interrupt* pierces through the shape to the background. *Interrupt* can be achieved with a cutout, an erasure, or a punch through.

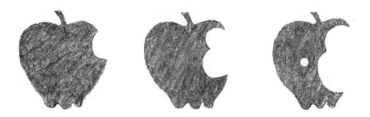

When you *interrupt* the edge of a flat shape—for example, take a bite out of a paper apple—it changes the profile. The background behind the image (in this case, white paper) will show through wherever the shape is *interrupted*. Using the *DO-TO* action of *interrupt*, you can also punch through the inside of a shape—like a wormhole. Think of this type of *interrupt* as taking something away from the shape's inside, which then shows through to the background under the shape.

Exercise 2: Pick a topic and tell a small visual story (in three steps) that shows a shape being *interrupted.*

[***Tip for Interrupt:*** When you *interrupt* an image, the ***removals*** are helpful to consider (see page 31).]

INSERT This action is like a spot tattoo or an area tattoo. It is not adding onto or piercing a shape, it is overlaying it—putting something inside the shape. Anything *inserted* in the shape needs to be a different color, value, or texture than the background—or the shape. (Here's why: Assume a black shape on a white background. The *insert* of white into the black shape would look like an *interrupt*. The insert of black into the black shape would merge and disappear to the eye.) Below, the *inserts* are shown as gray. Both examples are valid for **insert**. It does not *interrupt* or *add* onto the outside of the host shape. *Insert* acts like graffiti.

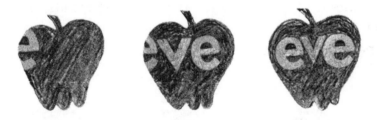

The sequential sketches below show two images (the lettering "eve" and the apple), as they perform the *DO-TO* action of *insert*. The black apple on a white background is the host shape. Once again, think of the apple images and the gray "eve" lettering as paper cutouts. So, when you use the *DO-TO* of *insert* (to place a shape inside another shape), the exterior edge of the host shape is not altered in any way; neither can you see through to the background. Eve overlays the shape and does not extend beyond the edges.

Exercise 3: Pick a topic. Tell a visual story (in three steps) that shows an *insert*.

[*Tip for Insert:* You can *insert* a *line*, a *plane*, *a photo*, *a pattern*, *a value or a color*, but your *insert* cannot match your background—or it would look like *interrupt* (which allows the viewer to see the background through the shape). You also could start with a background of pattern, color, even a photo. Play around with this idea.]

***Exercise 4:* Try all three *DO-TOs* in Combination!**

Begin with a simple flat apple *shape* that has no leaf. Then think about the concepts of *add*, *interrupt*, and *insert*. For interest, make things large, medium, and small as you work—that applies to the empty spaces as well as the filled up spaces.

 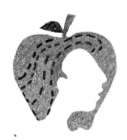 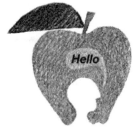

Add a *small* leaf. Then *interrupt* the apple with a *large* Eve and *insert* Eve's hair (dotted lines) to cover a *medium* area of the apple surface.

Add a *large* leaf. Then *interrupt* the apple with a *medium* Adam and *insert* a small "Hello" speaking bubble.

Add a *medium* leaf. *Insert* a snake image to cover a *large* area of the flat apple surface. Then *interrupt* the apple with the *small* snake eye.

In summary: The *DO-TO* of <u>Insert</u> is about making a change to a surface, not an edge. For a simple example, you could start with a cutout of a *circle*, *triangle*, or *square* on a white background. You could fill the whole shape by inserting a *color*, *texture*, *pattern*, or a *photo*. For example, you might fill a *circle* with the photo of a penny; or paint a yellow dashed line down the middle of a solid gray *triangle* to suggest a road in perspective; or draw a ribbon with wrapping paper inside a *square* to suggest a gift (no bow added to the outside or that would be *add*).

Whereas, The DO-TOs of <u>Add</u> and <u>Interrupt</u> are about structural change to a shape. *Add* some rays to a *circle* to suggest a sun; or *add* a shaft *(a line)* with feathers to a *triangle* to suggest an arrowhead; or *add* a long slim rectangle to the bottom of a *square* to suggest a hat brim. **With the *DO-TO* of *Interrupt*,** cut lines through a brown *circle* of paper to suggest a basket ball; or punch three holes along the edge of a *square* sheet of paper to suggest school notebook paper; or cut out windows and a door in a paper *triangle* to suggest a ski chalet.

Use a Triangulation Chart to think about how to use the Three *DO-TOs*

This diagram shows you all the choices available to use the *Do-Tos* separately or in combination. The apples on each point of this triangular diagram are examples of the three separate *DO-TOs*: **insert**, **add**, and **interrupt**. Apples in the middle of each side of the triangle show the mix of examples on either end. The free-floating apple in the center of this diagram combines all the *DO-TO* actions. [Note that the *DO-TO* action of *interrupt* punches through the apple shape with a "wormhole," and takes a "bite" out of the edge (in the shape of Eve's head). The word "SEEDS" lays on the surface of the apple shape and represents the *DO-TO* action of *insert*. The leaf added to the apple stem, represents the *DO-TO* action of *add*.)

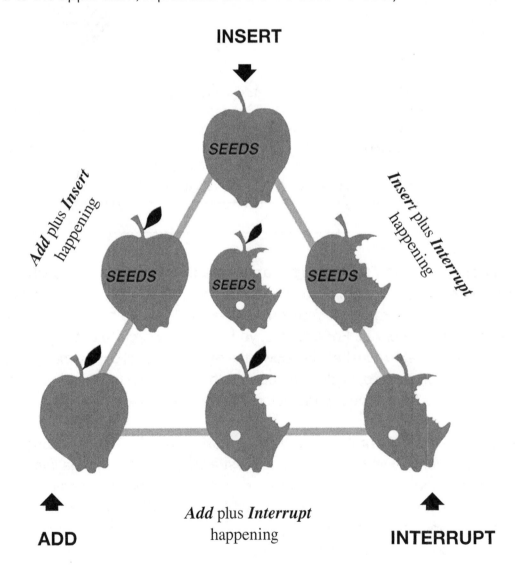

- ● *The 3 Links of Change* *(apart, touch, blend)*—**pertain to proximity**
- ● *The 3 Categories of Change* *(change of amount, change of place, change of quality)*—**pertain to general types of change**
- ● *The 3 Methods of Change* *(spatial depth, figure/ground exchange, planar shift)*—**pertain to perceptions of movement in flat space**

Before you begin, this section, here is an important concept to grasp: Although, each of the three main classifications of change will be introduced separately—***Links, Categories, Methods***—**they are often happening simultaneously.** For instance, in a small "movie" or visual story, about a school of fish in an aquarium, the audience might see the number of fish increase *(change of amount* is one of the general ***categories of change).*** As the fish swim together, the audience will watch the fish relate to one another by different ***links of change*** *(apart, touch, or blend).* The varying angles or positions from which an audience views the school of fish might be described as observing different ***methods of change*** *(spatial depth*—as they turn directions in space; *figure/ground exchange,* as the camera zooms in or out; or *planar shift* as they swim from one location to another. If this seems confusing, reread this paragraph again as you go through the next section and it will become clearer.

THE 3 LINKS OF CHANGE <u>Links</u> are about the physical proximity of things. They can be: 1. ***Apart,*** 2. ***Touch,*** or 3. ***Blend.*** It's about how things connect as change happens. In a *sequence of change,* images might start ***Apart*** from one another. Then move in closer to ***Touch,*** and then ***Blend*** together (merge).

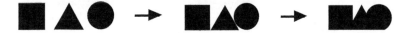

The three *Links of Change*—*apart, touch,* and *blend*—were combined to create this apple illustration.

This section is about general _categories of change_: 1. **Change of Amount**, 2. **Change of Place**, and 3. **Change of Quality**.

1. *Change of Amount*

Both examples to the right, portray a *change of amount* (a small object increased to a larger size; a single object increased to a larger number).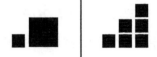

 In this part of the book, I use small visual stories to illustrate concepts. Below, are three rows of falling apples that sequentially demonstrate **Change of Amount**. However, the **top row**, portrays apples falling into a bowl *apart* from each other. The **middle row** portrays the same action, but they *touch*. And the **bottom row** portrays the apples *blending* together as they fall.

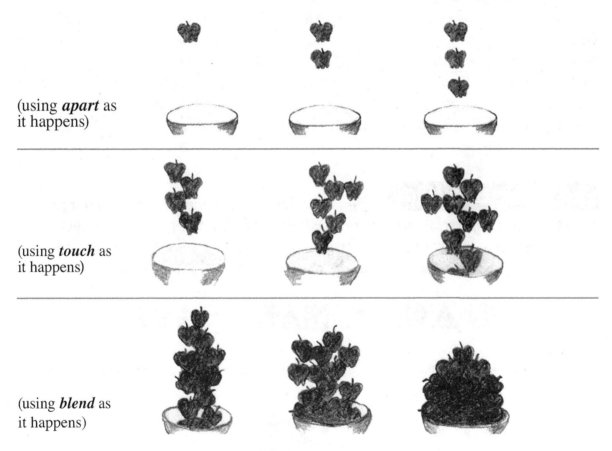

(using *apart* as it happens)

(using *touch* as it happens)

(using *blend* as it happens)

Change of Amount increases or decreases the number or the size of something —how you do that is up to you. Different types of change can happen simultaneously.

2. *Change of Place* (change in position or location). Here is a geometric example:

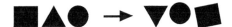

Remember that *Links*, *Categories*, and *Methods*—often happen simultaneously.

Below, in the **top row**, the letters that spell "cider" move *apart* and settle into *a Change of Place,* and new order. (The spelling and meaning have now changed.) In the second example the letters in the word APPLE overlap, move *apart*, and come back together, in a reverse overlap.

The **middle row** shows pieces of pie changing position—starting *apart*, then *touching*—first at their points, and then along their edges.

The **bottom row** shows the word APPLE in three different grays. They are stacked, but *apart*. As the words move, the different values of gray *touch*—and as the group arrives at a new *place*, the letters *blend.* The examples below all achieve *Change of Place* in different ways.

(*apart* helped to create this *change of place*)

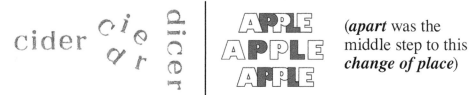

(*apart* was the middle step to this *change of place*)

(*apart* and *touch* helped to create this *change of place*)

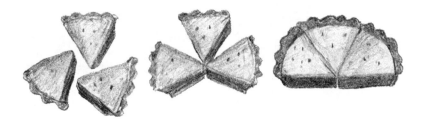

(*apart*, *touch*, and *blend* helped create this *change of place*)

3. **Change of Quality**. This is about a change of identity or a transformation—such as going from a pollywog to a frog. Here is a simple geometric example of **Change of Quality**.

The *DO-TOs* will be used in the following apple examples to demonstrate a **Change of Quality** (aka: a metamorphosis).

The **top row** uses the *DO-TO* of *interrupt* to *change quality.* The **middle row** accomplishes it with the *DO-TO* of *insert*. And the *DO-TO* of *add* is used in the **bottom row**. (Although **Change of Quality** is the dominant thought in these examples, influences such as the *DO-TOs* can be used to assist a change.)

(using the **DO-TO** of *interrupt* to **change quality**)

(using the **DO-TO** of **insert** to **change quality**)

(using the **DO-TO** of **add** to **change quality**)

A _method of change_ is about portraying movement as it pertains to the viewer, the object, and the working space. We will look at three _methods_ (specific ways) to do that. They are 1. **Spatial Depth**—how shapes move or turn in space; 2. **Figure/Ground Exchange**—the way the foreground and background contribute to the identity of shapes; and 3. **Planar Shift**—how shapes move (shift their position) across a flat plane.

1. The first _method of change_ we will look at is **Spatial Depth**. It implies movement of the object in space or movement of the viewer.

(Example: **Viewer changes position to object**—or object changes position to viewer)

Below, note the _foreshorten_ action that take place as the viewer's position in relationship to the cider jugs change. **Spatial Depth** can be used to create a sense of three dimensional space on a flat 2-dimensional _plane._

2. The second _method of change_ we will look at is **Figure/Ground Exchange**. This change relates to _foreground/background interplay_. A focus on the background space is unexpectedly exchanged for a focus on the foreground image (or vice versa). The new perception reveals something which before was not readily perceived. **Figure/Ground Exchange** can be achieved by a change of magnitude in the viewing distance. (Note on next page, the apple cider example of _figure/ground exchange._)

(Example: **zoom in —or out** on an object or shape)

 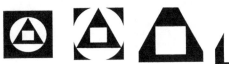

This example of **Figure/Ground Exchange** further illustrates the same concept shown by the geometric example, on the previous page.

3. Below, is the third <u>method of change,</u> **Planar Shift**—a directional movement of a flat shape across a flat surface. A good example is a chalk eraser's movement across a chalkboard. **Planar Shift** could be as simple as this example:

(Example: **Object moves in any direction across a flat surface**)

This sequential movement of a **Planar Shift** (example below) uses a sliding movement to *shift* position. Both the jug and the cider *shift* positions on the surface *plane*. In the drawing, the cider content remains a flat *plane*. As the jug sequentially tilts, the contents slide out across the surface to occupy a new place. In this case, it also takes on a new identity, becoming a cup, thereby changing *quality,* as well. The amount of area or "volume" represented by the transferred liquid technically remains the same—it just occupies a new space on the surface of the composition in the new form of a cup. (A cook might liken this to displacement that happens when solid ingredients are added to a liquid. The volume of liquid doesn't change, it just *shifts*.

[Below, the volume of liquid sequentially *shifts* across the page to a ***change of place.*** At the same time a metamorphosis (***change of quality)*** takes place as it becomes a cup. All of this is achieved through a ***planar shift*** move.]

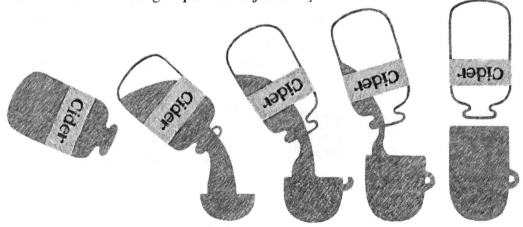

IS A CHANGE GRADUAL OR SUDDEN?

A *gradual* visual change happens over several observable steps. A *sudden* visual change is a sharp contrast, like a light switch turned on or off.

Gradual *Sudden*

In the next three examples: The **top row**, shows a *sudden Change of Amount*—a few blossoms to many blossoms. The **middle row** shows a *sudden Change of Quality*—from spring blossom to summer fruit. The **bottom row** shows a *sudden Change of Place*—from attached to falling.

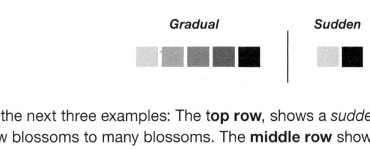

Sudden Change of Amount

Sudden Change of Quality

Sudden Change of Place

69

To achieve these exercises that show *gradual* change, you may use black and white or gray, and any parts of *The Design Code* you'd like.

The 3 Links of Change *(apart, touch, blend)*—refers to proximity-based movement.

Exercise—Tell a story of change in three or more steps—something that starts **apart**, moves in to **touch**, and then **blends**.

The 3 Categories of Change *(amount, quality, place)*—refers to general categories of change.

Exercise 1—In three or more steps, tell a story of something that changes in **amount.**

Exercise 2—In three or more steps, tell a story of something that changes in **quality**.

Exercise 3—In three or more steps, tell a story of something that changes its **place** (position or order).

The 3 Methods of Change *(spatial depth, figure/ground exchange,* and *planar shift)*—refers to the specific ways things move in space.

> ***Exercise 1***—In three or more steps, tell a story of something that turns in space and creates a sense of ***spatial depth*** for the viewer. In this example, the apple appears to move away from the viewer.

> ***Exercise 2***—In three or more steps, show what happens to a sense of identity in a ***figure/ground exchange***. *(zoom in, zoom out)*

> ***Exercise 3***—In three or more steps, show a ***planar shift*** from one position to another, across the flat *plane* of the page).

[***Special Note:*** Any move from one position to another is ***change***. The specific category, ***"Change of Place,"*** is found under the general ***Categories of Change***. However, specific *methods* of *how* to move something from one position to another are found under ***Methods of Change***. And, ***Links of Change*** concern proximity relationships as movement takes place (***apart***, ***touch***, or ***blend***). Do not be confused by this, there is no contradiction, they actually work together as concepts.]

Here's an example: Starting with an object of your choice, choose a category from ***Categories of Change*** that you'd like to demonstrate—let's say you picked ***change of place*** (distinct from ***change of amount*** or ***change of quality***). Your visual story will be about moving your object from one place to another. You've decided to slide it sideways across a page to sit next to another object (to do that, you use ***planar shift*** from ***Methods of Change***. You also decide to ***touch*** the other object with your object when your move concludes (that is using the physical link of ***touch*** *from* ***Links of Change***). If you then change your mind and move your object away from the other object, you would use the *link* of ***apart*** (also from ***Links of Change***).]

Thinking skills learned in the arts are transferable and appreciated in any domain of activity.

A key attitude fostered by participation in the arts is: <u>Do not give up</u>—that there are multiple ways to solve problems and that there is not just one correct answer in any given situation.

In academic circles, ***flexibility, fluidity, elaboration***, and ***originality*** are recognized as the basics skills of creative problem-solving. ***The Design Code promotes these skills through:*** Ease in shifting perspective (flexibility); quick generation of many ideas (fluidity); building on those ideas with other ideas (elaboration); and conceiving something new or finding a new use for something that already exists (originality).

The place to master these skills is in your sketchbook practice (paper or digital). Armed with *The Design Code* and faced with a blank page or screen, you no longer have to start from scratch. You now have an entire arsenal of basic visual approaches to choose from.

The principles found in *The Design Code* are universal principles used by all artists, consciously or unconsciously. The terminology may very, but there are many systems and ways to learn these principles. *The Design Code* is just one way to do it, but it is a way that has successfully worked for many students and professionals. I have found it a unique and comprehensive tool in my visual arts war chest

The concepts in this book were presented in an orderly sequential book format—however, creative thinking, by nature, is messy. Now that you've been through *The Design Code*, you are free to mix any concept with any other concept—to leave out a large part of the concepts or concentrate on just a few. Think of it as a collection of basic ideas that you can combine to express yourself in more complex ways. Once you are familiar with *The Code*, you won't have to think about it—just let it flow and use what works for you!

Would you like to see samples of these concepts used in real-world situations? I will leave that task to you—in the form of an ongoing personal scavenger hunt—because basic design principles found in *The Design Code* are all around you! Start to notice these concepts on the web, in newspapers, magazines or printed pieces—and real life.

Some good examples are in the "photos of the day" sections of most news media. Often a photographer will wonderfully, but unknowingly, capture one of the *compositional devices*. A process of consciously observing, develops a heightened sense of visual awareness and improves your skill as a visual thinker. So I encourage you to start your own file of examples.

I also suggest that good sketchbook practice, would be the following: Choose a topic, from man, civilization, or nature, and run it through the eight *compositional devises*—then keep it as a weekly discipline!. Stick with one topic for each set of eight you do. (Fred Griffin, developer of *The Design Code*, and my mentor, often used this as a warm-up exercise to start classes.) I gave my college design students an extended version of this exercise, and remember one memorable presentation that had the theme of a garden. Each of the eight *compositional devices* was beautifully presented as a different facet of "garden," and each was a small masterpiece! One was of a garden shovel, another featured a patch of vegetables, another spotlighted a garden hat, another, seed packets, etc. In the past, I've also enjoyed seeing students do visual essays with the eight *compositional devices* on topics such as: trains, wolves, delicatessens, an illustrated epic poem, fly-fishing, specific countries, geological land formations and historical events—to mention a few. Since the eight *compositional devices* can apply to photography as well, some students chose the camera as their tool to explore the eight *compositional devices*.

In conclusion: Encourage yourself to play! Ideas are unlimited. Design principles only guide thought. They are not rigid absolutes—just tools. Every composition creates *order* with *interest* in varying degrees. And everything is on a sliding scale (at what point does a dull apple become shiny?).

I've always liked this quote of Josef Albers: "In writing, a knowledge of spelling has nothing to do with an understanding of poetry."

The Design Code provides insight—but, what *you* do with it—that is <u>*your*</u> creativity, <u>*your*</u> imagination, <u>*your*</u> poetry.

So, with that, I wish you many happy hours of sketchbook play!

Friendly Sparring Match

William Cumming: author of <u>Sketchbook—a Memoir of the 1930s and the Northwest School</u>: University of Washington Press (2005); instructor at Art Institute of Seattle; Northwest painter represented by Woodside/Braseth Gallery

"For many years, Fred and I have been engaged in debate over the relationship of graphic design to expressive drawing and painting. I see Fred as driven by an irrational faith in the power of logic. I see myself driven by rational motives to the use of magical methods in painting and drawing. . . .Our students see the difference crystallized in Fred's advice 'to think before acting,' as against my advice 'to act before thinking,' In practical problems, Fred and I virtually always reach the same conclusions, although from radically separate starting points. In my own work it is impossible to determine just how much is impelled by the energy of our 'debates,' but I am certain that it is a great deal."

Knowledge of The Design Code Improves Watercolor Instruction

Jess D. Cauthorn: member of the American Watercolor Society and Puget Sound Painters group; retired Director/Owner of The Burnley School of Professional Art (now Art Institute of Seattle); past President, The Art Institute of Seattle

"My efforts in recent years are related to adults learning watercolor painting and they really don't want to think too much—but I find Fred's large-medium-small plan is easy to grasp and is about all the 'design' they can handle. Griffin's concepts work equally well for fine art as they do for graphic design. It *really* does help make better paintings for everyone. I constantly make reference to ad design, something they can see everyday and relate to. Good ads still use that principle—so do good paintings."

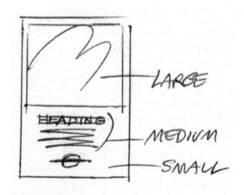

A *"No-Rules" Artist Wrestles with* The Design Code

Doug Fast: award-winning designer/art director; exhibitor in CA, PRINT, Graphic Design USA, Typography, AIGA, Architectural Signing and Graphics; mentioned in Walter Crowley's <u>Rites of Passage: A Memoir of the Sixties in Seattle</u>: University of Washington Press (1995-10)

"Fred was the reason I stayed at Burnley School of Professional Art for all three years. I have always been a 'no-rules' type and have always believed in achieving a solution to a design problem by attacking [!!] the problem head-on. . . . I think what Fred gave me is the ability to see quickly the merits of exploring—or not exploring—avenues of problem-solving, and upon finding a solution, the ability to nail down a strong design."

Praise for Unorthodox Instruction

Gary Nelson: program director, Graphic Design Department Highline Community College, Des Moines, WA

"Early in my career, I met a man who profoundly changed my way of looking at the world. Fred Griffin is a high-energy guy . . . who lives art in its purest form and is not concerned so much with outcomes as he is with the process of creation. Over the years I've studied and applied many design theories, but I always come back to the design system that I learned while studying, and later working, with Fred Griffin."

A Visual Grammar

David Rosenzweig: author of <u>Spend Less—Sell More, 13 Simple Steps You Can Take Right Now to Grow Your Business</u>: Probus Publishing Company (1994); marketing director

"Fred Griffin taught me how to articulate creative expression. The visual language that he taught me fifteen years ago when I was a student is still the composition that defines my work as a professional designer."

(Testimonials continued on next page)

A Winning Combination

Ted Leonhardt: designer/owner of award-winning The Leonhardt Group (offices in Seattle and London)

"Fred Griffin was both the most terrifying and the most brilliant professor I encountered as a student. I found Fred's design language to be a great tool. It brought a sense of order to my thinking."

Finding Inspiration Everywhere

Lisa (Hanson) Hixon: graphic designer and home school instructor

"On the first day of class, Fred Griffin walked around the room talking about design. He was lecturing about contour continuation and design terms—concepts that were new to most of us. Suddenly he stopped, looked down at the floor and exclaimed. 'There's a squirrel right there!' Everyone perked up. He bent own, and with his pen, made a few marks in the wood-grain and—sure enough—there was the squirrel! Before I took his class I used to see faces and animals in things around me. I still do and it was a delight to watch him see them too! I currently rely on his concepts when working in home school programs with other home-schoolers. To me, the thinking behind his system is not just limited to art."

From Discouragement to Success

Rosalyn Carson: graphic designer and art school instructor

"After completing my 2nd quarter of graphic design at the University of WA, my professors felt that 'I didn't have what it takes' and advised me to drop out of the program—they gave me one quarter to turn things around. Devastated and depressed, I sought outside advice. Diane Solvang-Angell reviewed my work and recommended I try *The Design Code*. I then enrolled in her class at a local college. With Diane's guidance I applied *The Code* to my third quarter graphic design project and got an A! I feel that knowledge of *The Design Code* enabled me to complete my BFA in graphic design. Afterward, I moved to the San Francisco Bay Area and worked for graphic design firms, ad agencies, corporations, and publishing houses—among them, *Sunset Magazine*. Today, I am an instructor for The Community School of Music and Arts (CSMA) in Mountain View, California, in the 'Arts 4 Schools Program,' and bring sequential art lessons to kinder through 5th graders at my neighborhood school."

76

No one set of rules, guidelines, or systems can address all questions concerning visual expression. You will find that the books reviewed in the following section will enrich and complement what you already know.

Principles of design (the building blocks of composition) are universal basic truths. They are ideals. Sometimes in describing them, people use different terminology or choose to present them in different ways. Computer software apps may also refer to them with differing terms. Don't be confused by this: The basic principles of design—*never* change—only the way they are described or presented.

Above are a couple of shelves from my collection of art, writing and design books. I picked out some favorites to review for you—each one offers something a little different—unique insights to design principles, art, and creativity. In this book review section, note my subheads that group them under specific categories. Enjoy!

SUGGESTED READING

Some of these are classics—seminal or landmark works. You can find them online or at new and used book stores. Many can be found at the public library. Specific reference information is listed after each group of short reviews.

■ *On Artistic Fear and Renewal*

For those who find inspiration difficult without other artists to share ideas, read: ***Art & Fear—Observations on the Perils (and Rewards) of Artmaking.***

For those who feel they've lost touch with a sense of innate creativity, read: ***The Artist's Way: A Spiritual Path to Higher Creativity—a Course in Discovering and Recovering Your Creative Self.***

A Life in Hand: Creating the Illuminated Journal and ***A Trail Through Leaves: the Journal as a Path to Place,*** are two books about artistic renewal that encourage keeping a visual journal. They are reflective sketchbooks that beautifully record nature.

Bayles, D. & Orland, T. (2001) . Art & fear—observations on the perils (and rewards) of artmaking. Image Continuum Press: Eugene, OR

Cameron, J. (1992). The artist's way, a spiritual path to higher creativity—a course in discovering and recovering your creative self. G.P. Putnam's Son's: New York

Hinchman, H. (1999). A life in hand: creating the illuminated journal. Gibbs Smith: Layton UT

Hinchman, H. (1999). A trail through leaves: the journal as a path to place. W. W. Norton & Company: New York

■ *For a More Intellectual Approach to Design and Thinking*

Try Edward de Bono's ***Lateral Thinking: Creativity Step by Step*** for unique insights. Edward de Bono is an expert on thinking processes. You will find *The Oxford Dictionary* credits him for its definition of *Lateral Thinking*. Two other books of his, while not specifically on *lateral thinking*, will enhance visual problem solving skills: ***Six Thinking Hats*** and ***Teach Your Child to Think.***

For a European flavor, you might enjoy an old classic by Swiss designer, Armin Hofmann, ***Graphic Design Manual, Principles and Practice.***

A more contemporary manual would be *Design Basics*. Its author, David Lauer, explains different categories of design principles and shows examples.

Approaching learning of design principles as a language is explored in a *Primer of Visual Literacy*, an M.I.T. publication, by Donis A. Dondis.

Art and Visual Perception, a Psychology of the Creative Eye—New Version is an established classic. Rudolph Arnheim applies psychology to the visual process that takes place when people create. He includes Gestalt principles of perception.

In *Design and Form*, a master educator from the original Bauhaus school in Weimar, Germany, Johannes Itten, shares his course in design. The Bauhaus had a profound influence upon subsequent developments in art, architecture, graphic design, interior design, industrial design, and typography.

Wucius Wong's *Principles of Form and Design* is a classic in fundamental art and design education, which is used in programs around the world. It covers two-dimensional and three-dimensional forms—abstract and representational.

Arnheim, R. (2004). Art and visual perception, a psychology of the creative eye, new version, University of CA Press

de Bono, E. (1999). Six thinking hats. Back Bay Books: New York

de Bono, E. (1994). Teach your child to think. Penguin: New York

de Bono, E. (1973). Lateral thinking: creativity step by step. Harper Colophon: New York

Dondis, D. (1973). Primer of visual literacy. MIT Press: Cambridge MA

Hofmann, A. (2001). Graphic design manual. Arthur Niggli: Switzerland

Itten, J. (1975). Design and form, revised edition, the basic course at the Bauhaus and later. Litton Educational Publishing: New York

Lauer, D. (2008). Design basics. Wadsworth Publishing. Florence, KY

Wong, W. (1993). Principles of form and design. Reinhold: New York

■ *In Exploring Clever Usage of Design Concepts, You Might Try Any of These*

The link between comic book action and graphic design thinking is unveiled by Scott Mcloud, in *Understanding Comics, the Invisible Art*; and in *Reinventing Comics, How Imagination and Technology Are Revolutionizing an Art Form*. The author talks about strategy, imagination, and what happens in the "empty spaces" between comic strip frames.

Milton Glaser Graphic Design, showcases one of the nation's top designer's inventive work—an educator, mover, and shaker in international contemporary design circles.

Visual Literacy, a Conceptual Approach to Graphic Problem Solving is a course in creativity and visual thinking that comes from two prominent instructors at The School of Visual Arts in New York.

A Kick in the Seat of the Pants: Using Your Explorer, Artist, Judge, & Warrior to be More Creative; and *Whack on the Side of the Head: How You Can Be More Creative*, are books by the same author that explore the creative process. He also developed a pack of cards called *Roger von Oech's Creative Whack Pack* that works as a tool to jump-start creativity.

The Graphic Work of M.C. Escher explores unique concepts of negative-positive composition, symmetry, the illusion of perspective, and transitions from flat space to three dimensional space.

René Magritte's surrealist work is featured in any books about *René Magritte*. His startling images challenge and tease the viewer's perception.

Bob Eberle's *Creative Games and Activities for Imagination Development: Scamper* was specifically written to encourage creative thinking in children.

Thinkertoys, a Handbook of Business Creativity for the 90s, reads like a catalog of creative ideas and exercises.

Eberle, B. (1997). <u>Creative Games and Activities for Imagination Development: Scamper</u>. Prufrock Press: Austin TX

Escher, M. (2008). <u>The graphic work of M.C. Escher</u>. Taschen: Cologne, Germany

Glaser, M. & Folon, J. (2009) <u>Milton Glaser graphic design</u>. The Overlook Press, Inc.: New York

McCloud, S. (1993). <u>Understanding comics, the invisible art</u>. Tundra Publishing: Northampton MA

McCloud, S. (2000). <u>Reinventing comics, how imagination and technology are revolutionizing an art form</u>. Harper Collins: New York

Michalko, M. (2006). <u>Thinkertoys.</u> Ten Speed Press: Berkley CA

von Oech, R. (1986). <u>A kick in the seat of the pants, using your explorer, artist, judge, & warrior to be more creative</u>. Harper & Row: New York

von Oech. R. (2008). <u>A Whack on the side of the head, how you can be more creative.</u> Warner Books Business Plus: New York

von Oech R. (1988). <u>Roger von Oech's creative whack pack.</u> U.S. Games System, Inc.: Stamford CT

Wilde, J. & Wilde, R. (2000). <u>Visual literacy, a conceptual approach to graphic problem solving</u>. Watson Guptil: New York

■ Books about Hands-on Design Principles and Examples

Remember our *Design Code* discussion about the *compositional device* of *structure?* We talked about space division and building—about the different ways shapes connect. ***The Grid*** is a book all about space division and structural building.

The 7 Essentials of Graphic Design is written by a graphic designer and award-winning instructor who recommends an approach to design that includes: research, typography, contrast, layout, the grid system, identity design, and doing a critique/analysis evaluation.

Hurlburt, A. (1982). The grid, a modular system for the design and production of newspapers, magazines, and books. Wiley: Hoboken, NJ

Goodman, A. (2001). The 7 essentials of graphic design. How Design Books: Cincinnati OH

■ Two Books on the Relative Power of Perspective

Zoom, charmingly zooms you through progressive visual perspectives.

Powers of Ten is a captivating flip book (and film) that expresses something similar to ***Zoom***, but with the relative size of things in the universe and the effects of adding another zero.

Banyai, I. (1998). Zoom. Puffin: New York

Eames. C. & Eames, R. (1998). Powers of ten flip book. W.H. Freeman & Company

■ Basic Drawing Concepts

Betty Edwards' classic, ***Drawing on the Right Side of the Brain***, has been revised and improved. She makes drawing enjoyable for any age, especially beginners.

Ed Emberley, an award-winning author and illustrator, teaches children (big children and little children) how to draw. His books are easy to follow. A child (or adult) will be drawing up a storm of animals, people, and things in no time!

Edwards, B. (1999). <u>The new drawing on the right side of the brain: a course in enhancing creativity and artistic confidence.</u> Penguin: New York

Ed Emberley's series of drawing books for children. LB Kids: Boston, MA

■ **Books on Optical Illusion and Foreground/Background Interplay**

Optical Illusions and the Visual Arts has good examples of *negative-positive* optical illusions in photography, fine art, and graphic art. "Optical illusions provide the viewer with the curious but undeniable pleasure of being visually deceived."

The Little Giant Book of Optical Illusions is a compendium of illustrated illusions that ask viewers questions about the illusions and provides answers at the back of the book.

Notan is not about illusion, but it is about how to control the balance of *negative* and *positive* space.

Carraher, R. & Thurston, J. (1966). <u>Optical illusions and the visual arts</u>. Reinhold: New York

Kay, K. (1997). <u>The little giant book of optical illusions</u>. Sterling Publishing Company: New York

Bothwell, D. & Mayfield, M. (1991). <u>Notan, the dark-light principle of design</u>. Dover Publications, Inc.: New York

■ **Some Helpful Books on Color Theory**

Interaction of Color will give you a basic background on color theory. Joseph Albers, the author, was an instructor at the renown Bauhaus School in Germany, and later served as head of the Department of Design at Yale University.

The Art of Color is by another former Bauhaus instructor, Johannes Itten. "As sound lends sparkling color to the spoken word, so color lends psychically resolved tone to form" and, "Color aesthetics may be approached from these three directions: Impression (visually), expression (emotionally), construction (symbolically)."

For a more contemporary read, try Wucius Wong's *Principles of Color Design*. It has three parts: *Design Principles*, *Color Principles*, and *Color Design*.

Albers, J. (2006). <u>Interaction of color: revised and expanded edition</u>. Yale University Press: New Haven

Itten, J. (1997). <u>The art of color</u>. John Wiley & Sons: Hoboken, NJ

Wong, W. (1997). <u>Principles of color design</u>. John Wiley & Sons: Hoboken, NJ

■ *For the Painter in You*

Learn Watercolor the Edgar Whitney Way is a well written and illustrated book from a watercolorist's viewpoint on designing composition.

Watercolor Techniques, Discover the Techniques of Successful Watercolor Painting —the brushes, the paper, the strokes. An easy-to-grasp, well illustrated how-to book, if you are a beginner.

Ronsan, R. (1997). <u>Learn watercolor the Edgar Whitney way</u>. North Light Books: Cincinnati OH
Topham, M. (1997). <u>The north light illustrated book of watercolor techniques, discover the secrets of successful watercolor painting</u>. North Light Books: Cincinnati OH

■ *More on the Balance of Order and Interest (the Structured Approach Versus the Emotional Approach)*

The Dot and the Line: A Romance in Lower Mathematics is a charming little book (and film) on the reward of a disciplined approach to design versus random groping.

The Way of the Brush is a look at Chinese culture and how its art can be described as technique (logic) woven in with myth and magic (emotion)—a different approach that balances order with interest!

Van Briessen, F. (1962). <u>The way of the brush</u>. Charles E. Tuttle Co.: Tokyo
Juster,N. (2000). <u>The dot and the line: a romance in lower mathematics</u>. Chronicle Books: CA

■ *And Now, If You Would Like to Depart Totally from the Thought of Logic-based Creativity . . .*

Then David Carson's *End of Print* and *2nd Sight* is for you. His work, originated from the skateboarder/surfer culture. In the 90s, he was a founding art director for *Ray Gun*, an American alternative rock-and-roll magazine. Based solely on emotion and intuition, he produced a style of design that changed an entire generation's way of approaching art and was also a big influence on advertising. Some thought his style was illegible and represented anti-communication. Others revered it. You can be the judge.

Blackwell, L. & Carson, D. (1997). <u>David Carson: 2nd sight: grafik design after the end of print</u>.
 Chronicle Books: San Francisco
Blackwell, L. & Carson, D. (2000). <u>The end of print: the graphic design of David Carson</u>.
 Chronicle Books: San Francisco

Tossing Around Ideas is the next book in this two book series.

If you would like another run through *The Design Code*, this time with an ocean theme, you will enjoy the next book.

Each book in this two book series on *The Design Code* illustrates the entire *Code*. The first book was limited to black and white examples, since color adds complexity to the learning process.

Tossing Around Ideas, is printed in color and you will find new examples to compare with concepts you have learned in this book. It will show how *The Code* can also apply to photography. Information about color theory is included—and a section devoted to exercises will challenge your creativity! There will be sketchbook encouragement, and you will see *The Design Code* used in a commercial situation— to develop a logo, brochure and letterhead for a hypothetical B&B located on cliffs above the ocean.

———————————————

"The notes I handle no better than many pianists. But the pauses between the notes—ah, that is where the art resides."

—Artur Schnabel

A

abstract 46, 79.
add(ed, ing) 7, 9, 20, 26, 46, 52, 57-59, 61, 62, 65, 73.
apart 46, 57, 63, 64, 66, 70, 71.
arrange(ing, ment, ments) 6, 7, 8, 23, 24, 38, 56, 40.
asymmetry (*asymmetrical*) 7, 9, 24, 25, 34, 36, 40.
author 4, 60.

B

background 24, 28, 38, 58-60, 67. (related: see *removals*)
balance(d) 7, 23, 24, 34, 36, 49, 83.
balance strategies 9, 23-25 56.
blend(s) 12, 57, 63, 64, 66, 70, 71.
branching 45, 55, 56.

C

cast shadow 32, 33.
categories of change 57, 63, 64, 70, 71. (see also, *links of change*; *methods of change*)
Cauthorn, Jess 74.
change of amount 57, 63, 64, 69.
change of place 57, 63, 64, 65, 69, 71.
change of quality 57, 63, 64, 66, 69.
circle 9, 16, 17, 61, 72.
classification system preface.
color 5, 6, 9, 16, 20, 21, 38, 42, 60, 61, 73, 82.
complex 48, 52, 72.
compose (composing) 6, 9, 35, 56.
composition(s, s', al) preface, 4-8, 10, 11, 24, 26, 28, 30, 34-36,
 38, 40, 42, 48-50, 54, 61, 62, 68, 73, 75, 77, 80, 83.
compositional devices 6, 8, 9, 10, 34-36, 38, 40, 42, 44, 56, 73.
concave and convex 38.
cone 17.
connect(ions) 9, 23, 28, 29, 38, 40, 63, 81.
consciously 56.
creativity 4, 72, 73, 77, 79, 80, 83, 84.
creative(ly) 37, 56.
creat(e, ion) 13, 75.
cube 17.
Cumming, William 74.
curve(d, s) 9, 14, 15. 40, 42, 56.

D

descriptions 9, 11-13, 54.
design preface, 4, 5, 7, 34, 72-83.
definition of design 7.

planar shift 57, 63, 67, 68, 71.
play(ed, ing) preface, 23, 34, 36, 46, 49, 52, 56, 61, 73.
poetry 84.
point 7, 24, 26, 28, 73, 74.
point-connect 6, 9, 28, 59.
pop-out 9, 30.
position 9, 32, 33, 35, 36. 50, 63, 65, 67, 68, 70.
primary status 50.
proximity 57
pyramid 17.

Q

Quick Reference and Overview of *The Design Code* Process (How It All Fits) 9.

R

radial symmetry 24.
random 5, 20, 44, 83.
recommended reading 77-83.
rectangle(s) (rectangular) 16, 32, 40, 61.
reference(s) 9, 23, 26, 27, 36, 74, 78.
reflect(ion, ive) 18, 19, 24, 28, 78.
reflect-out 9, 30.
relate 6, 9, 23, 28, 46, 55, 63, 67, 74.
removals 9, 23, 30, 31, 38, 59. (related: *negative/positive compositional device;*
 negative /positive interplay)
repeat(ed) 9, 10, 20, 24, 34, 35 38, 39, 44, 56.
repetition(s) 38.
representational 16, 46, 79.
role-play 15.
Rosenzweig, David 75.
rotate 24, 25.

S

scale 9, 32, 42, 52, 68, 73.
sequence(s) of change 57, 63, 70.
secondary status 50.
select(ion, ing, ed) 6-11, 34, 56.
semi-stylized 46.
shadow(s) 9, 32. (also, see *cast shadow; form shadow*; soft shadow; hard shadow)
shape(d, s, s', U-, V-) 5, 6, 9-12, 16, 17, 20, 24, 28, 30, 32, 36, 38, 40, 46, 52, 56-62, 6-68,
 71, 81.
sequence 42, 68.
size(s) 9, 20, 26, 32, 36, 38, 52, 61, 64, 81.
sketchbook(s) preface, 4, 7, 12, 22, 44, 46, 56, 58, 72, 73, 74, 78.
slice-off 9, 30, 31.
slide-out 9, 30, 31, 52.
soft-edged 48.

Cune Press was founded in 1994 to publish thoughtful writing of public importance. Our name is derived from "cuneiform." (In Latin *cuni* means "wedge.")

In the ancient Near East the development of cuneiform script—simpler and more adaptable than hieroglyphics—enabled a large class of merchants and landowners to become literate. Clay tablets inscribed with wedge-shaped stylus marks made possible a broad intermeshing of individual efforts in trade and commerce.

Cuneiform enabled scholarship to exist and art to flower, and created what historians define as the world's first civilization. When the Phoenicians developed their sound-based alphabet, they expressed it in cuneiform.

The idea of Cune Press is the democratization of learning, the faith that rarefied ideas, pulled from dusty pedestals and displayed in the streets, can transform the lives of ordinary people. And it is the conviction that ordinary people, trusted with the most precious gifts of civilization, will give our culture elasticity and depth—a necessity if we are to survive in a time of rapid change.

Books from Cune Press

 Aswat: Voices from a Small Planet (a series from Cune Press)

Looking Both Ways	Pauline Kaldas
Stage Warriors	Sarah Imes Borden
Stories My Father Told Me	Helen Zughaib & Elia Zughaib
Girl Fighters	Carolyn Han

 Syria Crossroads (a series from Cune Press)

Leaving Syria	Bill Dienst & Madi Williamson
Visit the Old City of Aleppo	Khaldoun Fansa
Stories My Father Told Me	Helen Zughaib, Elia Zughai
Steel & Silk	Sami Moubayed
Syria - A Decade of Lost Chances	Carsten Wieland
The Road from Damascus	Scott C. Davis
A Pen of Damascus Steel	Ali Ferzat
White Carnations	Musa Rahum Abbas

 Bridge Between the Cultures (a series from Cune Press)

Empower a Refugee	Patricia Martin Holt
Biblical Time Out of Mind	Tom Gage, James A. Freeman
Turning Fear Into Power	Linda Sartor
The Other Side of the Wall	Richard Hardigan
Apartheid Is a Crime	Mats Svensson
Curse of the Achille Lauro	Reem al-Nimer
Arab Boy Delivered	Paul A. Zarou

 Cune Cune Press: www.cunepress.com | www.cunepress.net

Diane Solvang-Angell: Author Profile

Print books on design and creativity (Cune Press.com)

eBooks on exploring digital art (iTunes/Apple Books)

Professional Education

MAEd: Antioch University Seattle

 (Thesis: *Integrating Pedagogies and Learning Approaches from the Arts with Other Academic Disciplines to Enhance Learning*)

BA: University of Washington

UW Professional & Continuing Education Certificates:

 Project Management, Screenwriting, and Documentary Filmmaking

Diploma: The Burnley School of Professional Art, Seattle

Summer Workshop: School of Visual Arts, NYC

Design Conferences: Aspen, Stockton

Professional Background—Educator, Illustrator/ Graphic Designer, Communications Marketing Manager, Author

Panel speaker, MDAC Creative Summit, Palo, Alto, CA—

 (Topic: "Mobile Digital Painting and Photography and Its Impact on the World of Fine Art and Art Education;")

Jurist—Rocky Mountain DMA Echo Awards

Publication Awards; New York Art Directors Annual,

 The Seattle Design &Advertising Awards;

 (IMCA) Insurance Marketing and Communications;

 Strathmore Paper Company Graphics Gallery

Seattle School Board's committee to define alternative education

Former Field Marketing Communications Manager,

 SAFECO Insurance—a Fortune 500 Company

Charter member/past secretary, Seattle Direct Marketing

 Association (DMA)

Former instructor The Burnley School of Professional Art

 (later became Art Institute of Seattle)

Former instructor Bellevue Community College—academic program,

 Design 109 (now Bellevue College)

Former 3-D Illustrator: art representatives San Francisco/Seattle

Past president Society of Professional Graphic Artists, Seattle

 (SPGA now merged with Graphic Artists Guild)

Author Diane Solvang-Angell resides in Seattle. She currently can be found overcoming frustration at the local pottery studio, as she tries her hand at wheel-throwing. She also plays melody on the autoharp. (For her professional experience in design and graphics see page 91.)

The author, discussing *The Design Code®* with its developer, Fred Griffin (also, see Preface, page 3; Author's Personal Note, page 4; and page 22)